SECRET
NEWCASTLE-
UNDER-LYME

Mervyn Edwards

AMBERLEY

First published 2017

Amberley Publishing
The Hill, Stroud
Gloucestershire, GL5 4EP

www.amberley-books.com

Copyright © Mervyn Edwards, 2017

The right of Mervyn Edwards to be identified as the
Author of this work has been asserted in accordance
with the Copyrights, Designs and Patents Act 1988.

ISBN 978 1 4456 6490 3 (print)
ISBN 978 1 4456 6491 0 (ebook)

British Library Cataloguing in Publication Data.
A catalogue record for this book is available from the
British Library.

Origination by Amberley Publishing.
Printed in Great Britain.

Contents

Introduction

If our title is *Secret Newcastle-under-Lyme*, then how do we define the 'secret' history of the town and its environs? Often, this book will feature aspects of history that are just too plain daft, odd or eyebrow-raising to have been included in other published works, yet such items tell us much about society in days gone by – to say nothing of the style of contemporary newspaper reporting. Countless examples are found in this book, but here's a taster, taken directly from the *Staffordshire Times* in 1875:

> SILVERDALE. CHASING A MONKEY.
> On Monday afternoon, a monkey belonging to one of the many travelling exhibitions which visit this neighbourhood, feeling desirous of a ramble, took an opportunity which presented itself and walked away, and seeing a 'Jerusalem' quietly grazing, and wishing to make his acquaintance, he leaped on his back, and now began a scene which created great amusement to the passers by. A gang of roughs, however, who constantly loiter near the Crown Bank, having got 'wind' of the affair, hastened down to the scene, and immediately tried to catch the little fugitive, who thinking he had not had liberty enough, ran away, and now began a chase, first in one street and then another, but seeing no hope of escaping the multitude, which was rapidly increasing every minute, the little fellow stepped into a house, and walked quietly down into the cellar. A collier present went in search of him, and soon returned dragging 'Jocko' at his heels, and handed him over to the roughs, who took him back to his master, and received the handsome reward of one shilling to be divided among them.

Accounts such as this shine a torch on our past. How must the equanimity and slothfulness of the Crown Bank loiterers have been happily disturbed by this rare, primate-pursuing fun? What chaos would have been created in the village as the guffawing youths gave chase?

There is the history contained within the manor court rolls, the parish registers, the Newcastle-under-Lyme Borough Council minute books, voluminous archive material, as well as the history written by Thomas Pape and others. Then there's ephemera: gold nuggets of information that touch upon the controversies and squabbles of the past, society's cranks and misfits and the engaging minor issues of yesteryear. This book represents an attempt to bring these items – mainly drawn from local newspapers – together. Like stray dogs, they've been rounded up and given a good home, so that in this book you will find quirky, amusing and sometimes shocking history that generally cannot be found in other books on Newcastle's history, whose organising principles are necessarily very different.

The material in this book proves that fact is often more jaw-droppingly stranger than fiction, but what is fact in any case? The readers' letters and editorial columns of nineteenth-century newspapers often offer a different perspective on news stories of the day, and are seriously under-used by historians as indicators of prevailing ideas that drove political developments.

Then there is the matter of oral testimony. It is interesting that such an august body as the North Staffordshire Historians Guild – whose gatherings I have attended – has shown interest in the radio recordings of Arthur Wood, who was a fervent supporter of oral testimony and who was particularly diligent in recording the memories of those who lived and worked on the canal boats in the early twentieth century. It is through the memories of older people that we can at least try to glean information that has gone unrecorded by historians. Consider some of the questions raised in the *Sentinel*'s 'Way We Were' over the years, such as where was the Icky Picky in Newcastle and how on earth did it get its name? And why was the Wammy in Knutton so called?

This book not only embraces Newcastle-under-Lyme but also some of its surrounding villages, hopefully giving it a broader appeal. It is a look at history 'below the surface', and I hope readers will be suitably provoked by its contents.

1. Communications

Newcastle-under-Lyme was both a road transport centre and a coaching town, and readers interested in this aspect of the town's history will find excellent background information in *Victoria County History* and *Newcastle-under-Lyme 1173–1973* by John Briggs (1973).

The story of turnpike roads in the area recalls the days of toll gates, toll bars, toll houses and the system whereby turnpike trusts levied charges on road users as a means of funding road maintenance.

The Wolstanton toll gate is referred to in a newspaper report of 1861, when a youth named James Madders passed through the gate without paying his toll and was impudent to the keeper. *Keates' Gazetteer and Directory* (1875–76) lists Eliza Baddeley as 'gatekeeper'. The gate was removed in October 1878 and the Lawton, Burslem & Newcastle-under-Lyme Turnpike Trust announced that the toll gate, notice boards, posts and rails would be sold by auction on 4 November. This press advertisement did not mention the toll gate house. Evidently, though, there was one in the village, as in 1881 a wall belonging to 'the Old Toll Gate house, Wolstanton' was knocked down by a milk seller from May Bank. By this time the cottage was the property of Thomas Edwards and was occupied by Mr Baddeley,

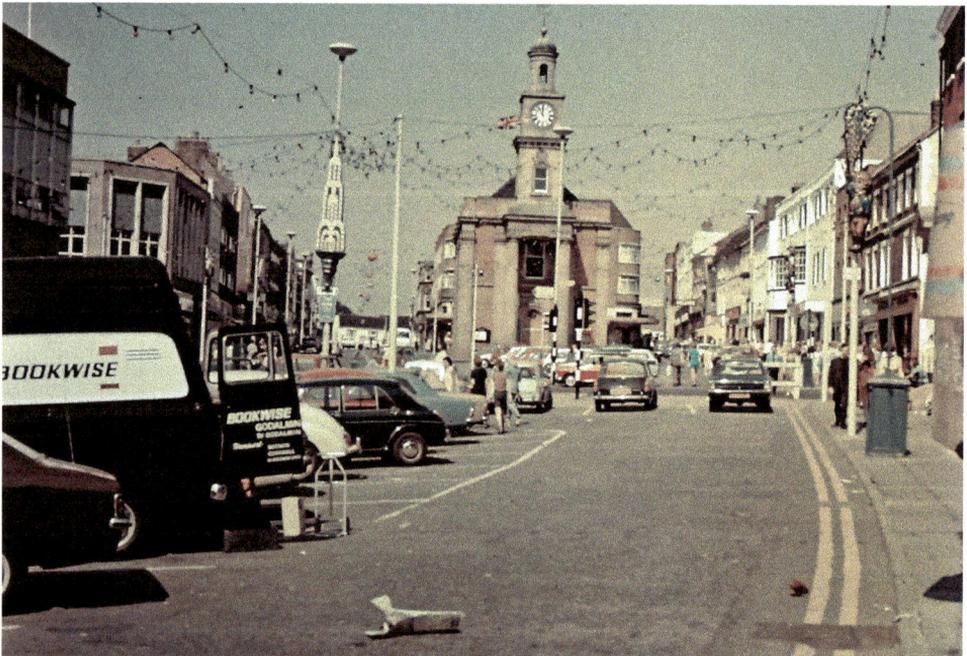

The Stones in Newcastle, early 1970s.

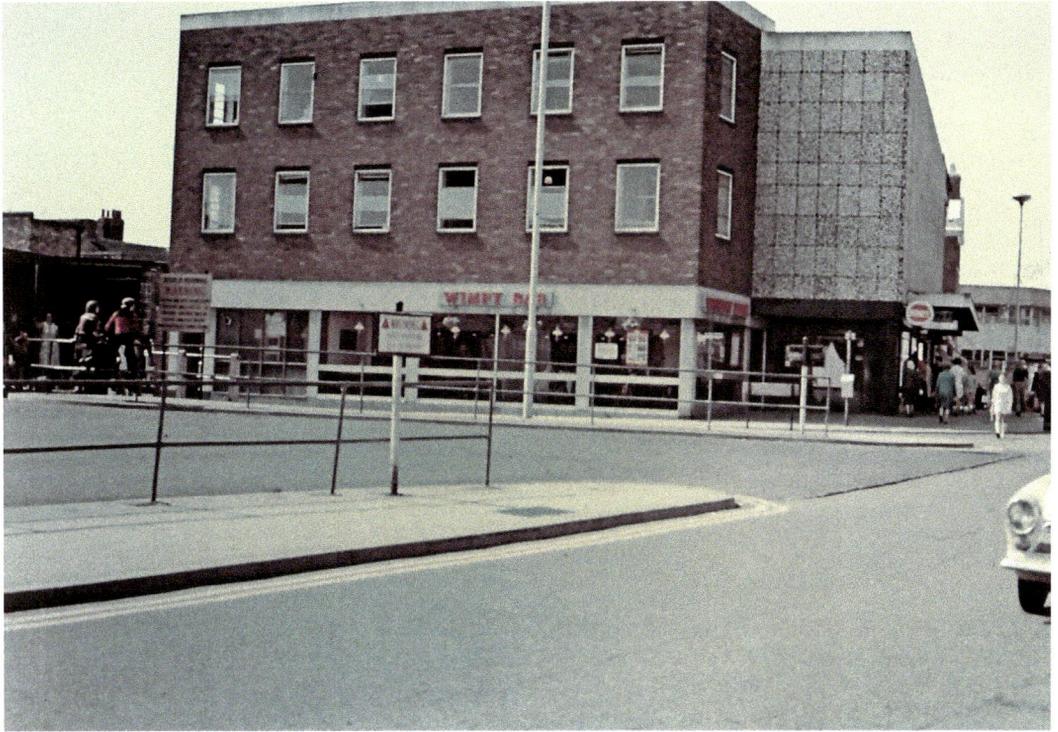

The Wimpy Bar in Hassell Street, Newcastle, in the early 1970s. The chain was launched in 1954, with these premises opening in April 1967.

a farm labourer. The errant milk seller, James Simpson, was a former tenant of the property, but perhaps had some grudge against the owner as he had been seen knocking the water closet down with a blacksmith's hammer.

Percy Adams, in *Wolstanton: Wolstan's Town* (1908), refers to the location of the Wolstanton toll gate: it was near to where Lily Street met High Street. Little else has been written about it, and few Wolstantonians today are aware that there was ever a toll gate in the village.

DID YOU KNOW?

In 1847 Mr Wright, a cattle dealer from Nantwich, backed his brown mare to accomplish the journey from the Globe in Red Lion Square, Newcastle, to the Market Hall in Nantwich within an hour – a distance of 16 miles. It was reported as an 'extraordinary trotting match against time', the fleet-footed mare negotiated what were, for the most part, poor road surfaces and made it home with a minute and a half to spare. She was ridden by her owner, who earned a considerable sum from the event.

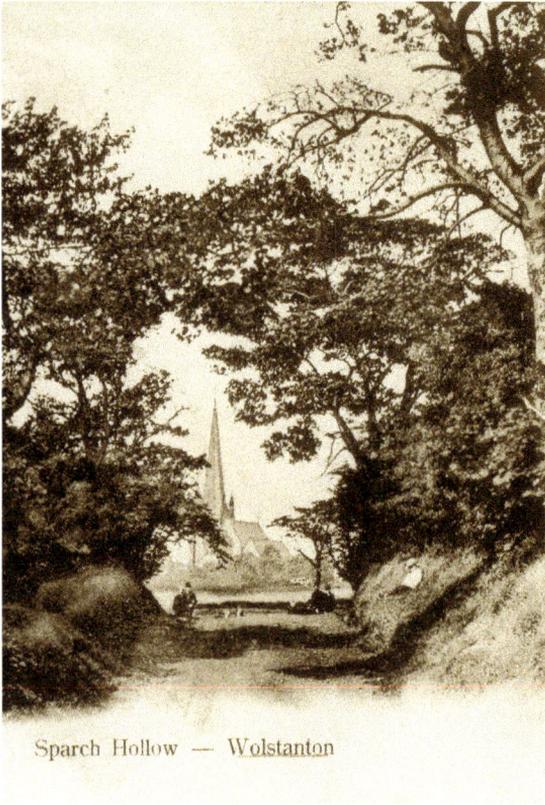

Sparch Hollow — Wolstanton

Sparch Hollow in May Bank was a narrow lane when this postcard picture was taken in the early twentieth century.

Though there are many of us who recall the days of the horse-drawn rag-and-bone carts, there are few people who remember when the working horses were regularly seen on the roads. Today's car-reliant society is a far cry from the days when horse droppings were a familiar sight on the roads and when private conveyances and tradesmen's vehicles were harnessed up to our four-legged friends. The potential for accidents through frightened and bolting horses is something that we do not consider today. However, a trawl through the nineteenth-century newspapers highlights the daily dangers faced by our forefathers. Many of these traffic accidents – like today's – could have been avoided.

A reminder of the horse-drawn traffic of yesteryear can be found in Market Lane, off Ironmarket, in the shape of guard stones, whose purpose was to prevent the wheels of horse-drawn vehicles colliding with and damaging the corner of a building or a gate. In 1842, a horse and cart had been left unattended outside the Bird in Hand pub. When something in the street frightened the animal, it set off at a pace up Market Lane, fortunately without injury to bystanders. However, at the top of the narrow lane, a wheel caught the stone outside the shop (which belonged to Mr Leek) and caused the horse to swerve into a lady who was coming up Ironmarket. The force of the horse and shafts threw her into Mr Leek's window, fracturing her skull and lacerating her forehead, but failed to stop the horse, which sped on up Ironmarket before violently coming into contact with one of the gateposts at the end of Roebuck Yard.

A frightened horse could certainly cover some ground, as we read from another press report of 1861. Colin Minton Campbell, the respected Stoke pottery manufacturer, and two other people were travelling in a phaeton along Albert Street into King Street when an 'inequality in the road' caused the vehicle to upset, turfing out the whole party. They suffered no real injury, but their horse, which managed to break free from its harness, galloped down the street into Ironmarket, drawing shrieks and shouts from bystanders. Reaching High Street, it ran into a window of the Roebuck Hotel and, slipping, fell. Rising quickly, it galloped down High Street and Penkhull Street, into Brook Lane and past the Boat & Horses pub and up into Clayton Road. It then sped through the Higherland and didn't stop until it reached the toll gate in Keele Road, where it stood quietly after its exertions.

DID YOU KNOW?
Samuel Dale of George Street, Newcastle, an electric tramcar conductor, was charged with being drunk on duty in 1916. He was found to be incapable of performing his duties while on the Newcastle to Silverdale route and sent home by the inspector at Newcastle. In court he claimed to have been ill rather than drunk, but the magistrates considered the case proved and he was fined 30s.

Ironmarket appears to have carried an attraction for runaway horses. Another one took fright and bolted down the street in 1873, its rider holding on for dear life. Upon turning the corner at the top of Ironmarket, the horse could not avoid rushing headlong into the plate-glass shop window of Mr Masterson, draper. Its rider managed to slip off without injury just before the crash. One woman was knocked into the window and badly injured.

Ironmarket, with early motor cars, probably in the 1920s.

The poor condition of many local roads gave rise to shocking accidents, especially in the days when street lighting was in its infancy and people were travelling at night. This is illustrated by a newspaper report in 1875.

William Sanderson hired a horse-drawn cab belonging to John Price of Stoke and asked to be taken to his residence in Halmerend. The evening was so dark that the cab driver – a Thomas Cornwall – later declared that he could barely see his hand in front of him as he negotiated his way safely enough through Knutton, where the road branched in two directions – one leading to Halmerend and the other across a coalfield, known locally as the School Ground Colliery or White Barn. This was not a public road and the danger it presented to anyone using it on dark nights such as this one gave full explanation as to why. It was reported that it would have been dangerous enough for a foot passenger, even one familiar with the area. A rather rustic entrance, consisting of two posts connected by a bar and suspended by chains, gave notice of this road's private status, but the barricade bar was said to have been down as often as it was up.

What made the road perilous was a large sheet of water to one side. 'The slightest deviation from the horse road would be sufficient to precipitate any vehicle into it.' By mistake, the cab driver proceeded down this road, managing to pass the pool safely, though the tracks left by his vehicle's wheels indicated how close the cab driver had been to an immersion in the water. Higher up the road, the surface became even more uneven, running along the edge of an almost perpendicular bank with a drop of between 100 and 150 feet. Here, one of the wheels ran over the edge of the road, resulting in the vehicle and its occupants being carried headlong down the incline. Around 50 feet down, the bank evened out in the form of a projecting ledge, which effectively checked the rapid progress of the cab. Had it not, the vehicle would have hurtled another 100 feet downwards into an old watercourse, very likely killing Sanderson, the cab driver and the horse in the process.

The stunned and bruised driver recovered his wits sufficiently to cry for help, summoning Inspector Harston (a Silverdale policeman) to the scene. He and Mr Butler of Knutton discovered the badly shaken cab driver struggling to climb the bank. The night was so dark that they could barely see his face until he was up close, and they had no idea that his vehicle had slipped over the bank until they were told. He was taken to Stoke Hospital, where he recovered from his injuries. Both Sanderson and the horse miraculously escaped without serious injury. It was reported that the affair caused considerable excitement in Silverdale and the immediate neighbourhood. It certainly underlined the hazards of travelling by road across the industry-scarred landscape in the late nineteenth century.

Drink-driving was all too common in the nineteenth century. In 1874 John Moreton, a butcher, was hauled before the magistrates on such a charge. He had driven his horse and trap at a furious rate through Church Street and Pool Dam on a Saturday night, failing to heed the shouts of a police officer. He collided with a horse-bus near the John O'Gaunt pub, upsetting his cart, breaking his axle and knocking a woman beneath his cart. What is really interesting about this report is that the magistrates' clerk saw fit to comment on the frequency of such incidents. He described market people driving home intoxicated as a 'crying evil'. He added that 'anyone driving from Betley, might, any Saturday night, meet some twenty or thirty carts, the drivers of which were either drunk or asleep. The other

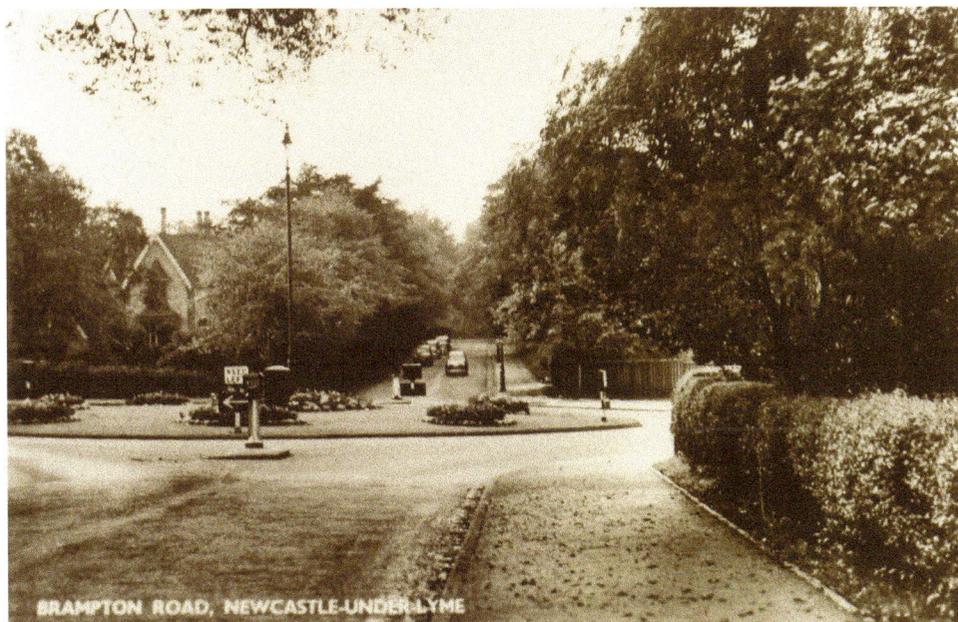

Brampton Road, Newcastle, at its junction with Sandy Lane, date unknown.

day coming from Silverdale he [Mr Dutton] within three or four hundred yards, met three carts, the drivers of which had to be woke.'

As Ernest Warrillow pointed out in his seminal history of Stoke-on-Trent, there were often altercations at toll gates when drunken road users refused to pay the toll gate keepers. However, in Wolstanton in 1866, it was the keeper himself who was the villain of the peace. William Cowan of Market Drayton was passing through the gate with his cart and after seeing no one there waiting to collect his toll, proceeded on his way. A few seconds later, the tardy keeper appeared. He pulled Cowan off his cart and roughed him up, cutting his lip and loosening three or four teeth. In court, the keeper claimed that Cowan had sustained his injuries by falling off his cart, but the magistrates were having none of it and fined him for a violent assault.

The same work contains mention of a horse-bus in 1874. Horse-drawn transportation was a public service that was developing quickly in Newcastle-under-Lyme by that time – partly triggered by the need to give the public better access to the railway stations. The issue of establishing a horse-drawn omnibus service between Newcastle and Etruria was discussed by Newcastle councillors in September 1875. Mayor Briggs suggested that such a service could only benefit the town and the public in general, especially as there was no quick way of getting from Etruria to Newcastle once a traveller had stepped off a train at Etruria railway station. Some councillors advocated co-operation with the North Staffordshire Railway – there was no question that such a scheme would be convenient. Many Newcastle people went to the station to book railway journeys, and, it was stated, around eighty trains per day stopped at Etruria. The mayor added, 'Anything which would tend to establish a closer communication between Newcastle and the Potteries would be

Newcastle railway station with the Borough Arms Hotel to the rear, 1960s.

a good thing.' Such a view foreshadowed serious discussions many years later regarding the benefits or otherwise of forging closer links between the two conurbations.

We conclude this chapter with a quirky snippet of history from Mow Cop, which is now in the urban district of Kidsgrove. It has been part of the borough of Newcastle-under-Lyme since 1974. Road accidents involving early motor cars and buses did not always occur through careless driving. Back then, roadholding on vehicles was not what it is now; this aspect of their design was certainly put to the test at Mow Cop. Known for its stone folly – dubbed 'Mow Cop Castle' by some – it stands 1,100 feet above sea level. Walking up is an appreciable test, but even ascending in a vehicle presents a challenge. However, in the summer of 1929, the *Sentinel* newspaper reported on a British lorry's 'Mow Cop climb'. Spectators swarmed to Mow Cop to see motoring history being made when a Morris Commercial lorry of 25 hundredweight, loaded with 2 tons and carrying two men in its cabin, made motoring history. The roadholding capability of the vehicle was crucial to its success, especially as wet weather attended the event.

Organised by John Pepper of Hanley, the main Morris Commercial distributor in North Staffordshire, the event could not have proceeded any better. The lorry was driven from the Piccadilly garage in Hanley, leading a mini motorcade including three other Morris Commercials and other cars bedecked with flags. This drew much attention as it passed through the Potteries towns to Mow Cop. Though the lorry came to a dead stop outside the Railway Inn (now the Cheshire View) the lorry was able to continue, tackling shifting shingle and turf made sodden by the downpour. The *Sentinel* reported, 'Along

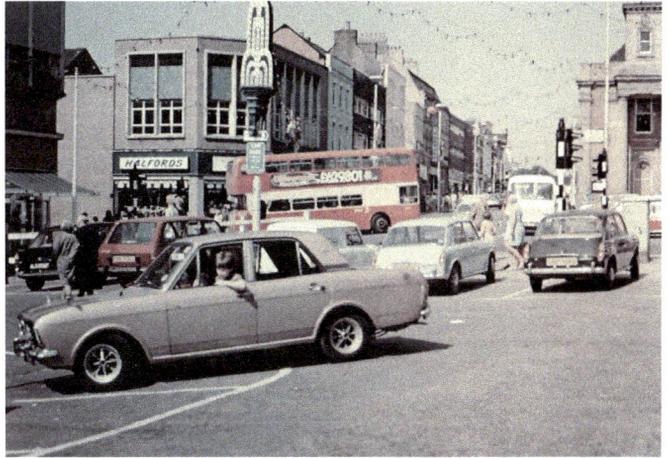

The Stones in the early
1970s, showing motor vehicles
of the time.

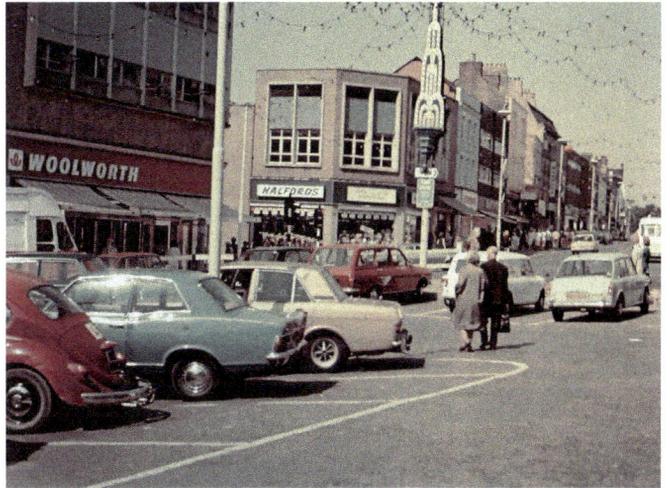

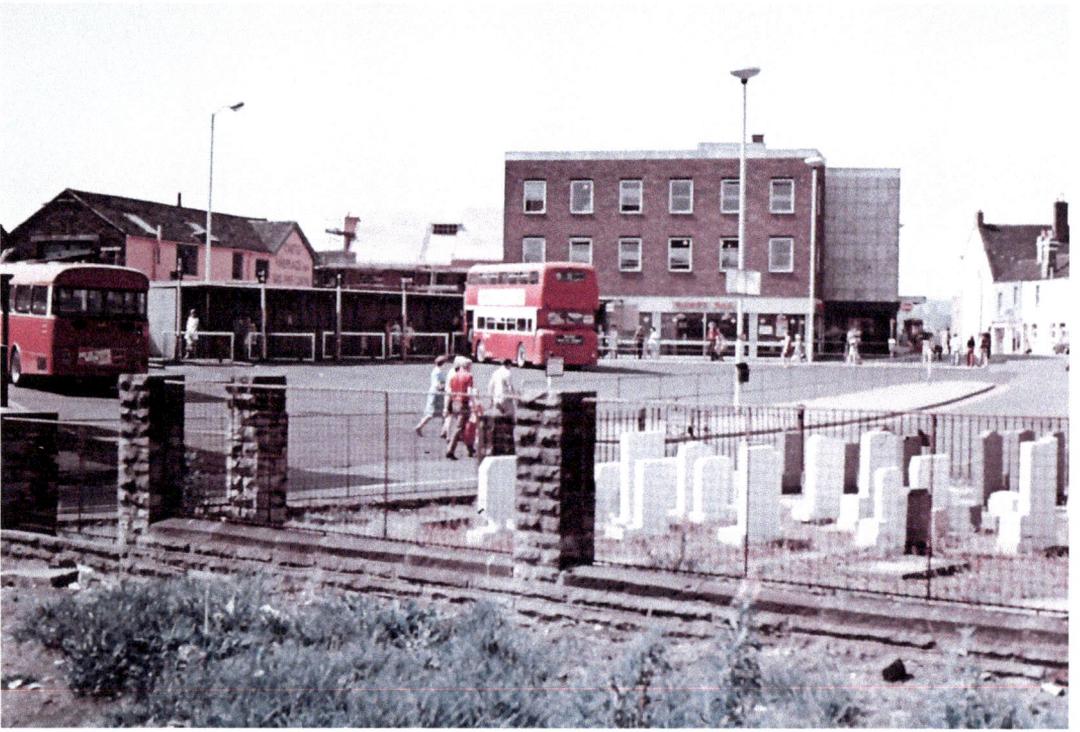

Newcastle bus station from Barracks Road, early 1970s.

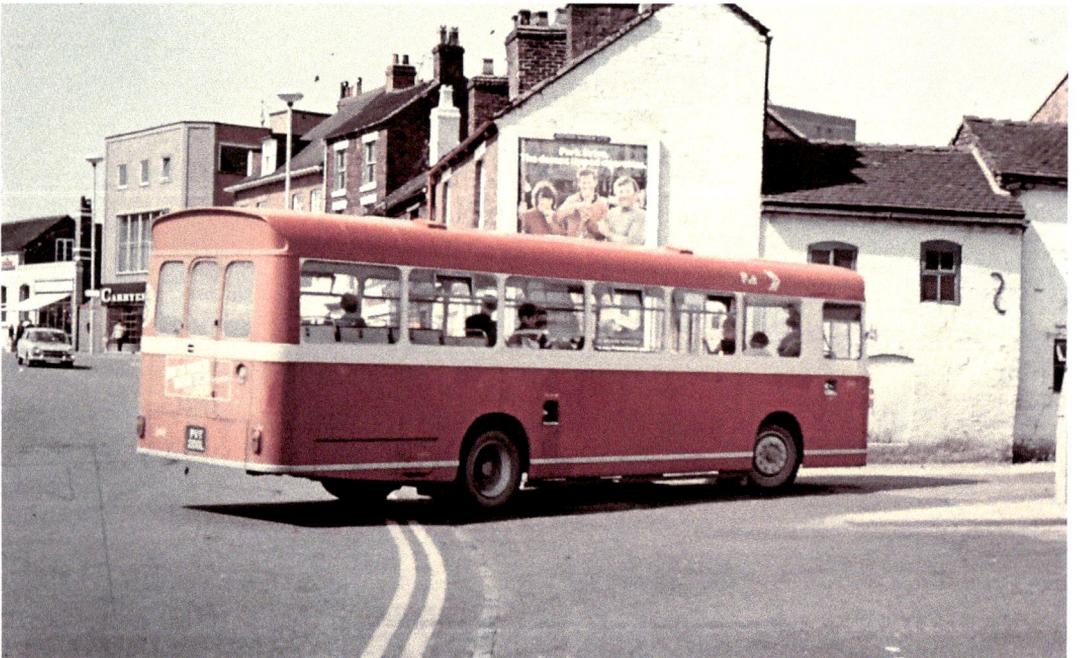

A bus entering Newcastle bus station, early 1970s.

tracks where its wheels rocked from side to side, between rocks less wide than its own base, the wonderful "25" pitched and rocked its determined way like a tank across some shell-ravaged No Man's Land.' The lorry skirted the local quarry only inches away from disaster as it negotiated the upper reaches of Mow Cop, being followed by a brand new Morris Minor with ladies standing on its running boards. Achieving its goal without a scratch, the lorry thus proved the excellence of British workmanship. The report in the *Sentinel* was accompanied by a conspicuous splash advertisement for the Morris Commercial lorry, its power and flexibility having been demonstrated by what had been a highly successful, crowd-pleasing publicity stunt.

DID YOU KNOW?

Newcastle railway station earned criticism for its inhospitable state in the local press of 1876. A ladies' waiting room was described as 'better calculated for use as a pig sty', while passengers in another shelter were said to be experiencing 'the benefit of a draught sufficient to winnow wheat'.

2. Industry

When we speak of factory conditions in the nineteenth century, we think of stifling, dangerous workplaces, the like of which are graphically described by factory inspectors and in novels such as Charles Dickens' *Hard Times*. The capitalist's genuine concern for the welfare of workers was a rarity, and that's why we must describe one man's visionary efforts to establish a model factory in Newcastle-under-Lyme in 1881. Many people will remember Enderley Mills, which was demolished in the 1980s – but what of its beginnings?

Richard Stanway opened his factory in Liverpool Road in 1881, having already prospered as an outfitter, tailor and draper in High Street. His enterprise had been recognised by contracts from central government, including one that required him to manufacture uniforms for the British army. Thus, it will be understood that Stanway's workload necessitated his removal to larger premises, providing room for various departments. He became a major employer in the town. His factory, at the top of Liverpool Road, occupied around an acre of land and, upon opening, the entrance to a new street – Enderley Street – was formed.

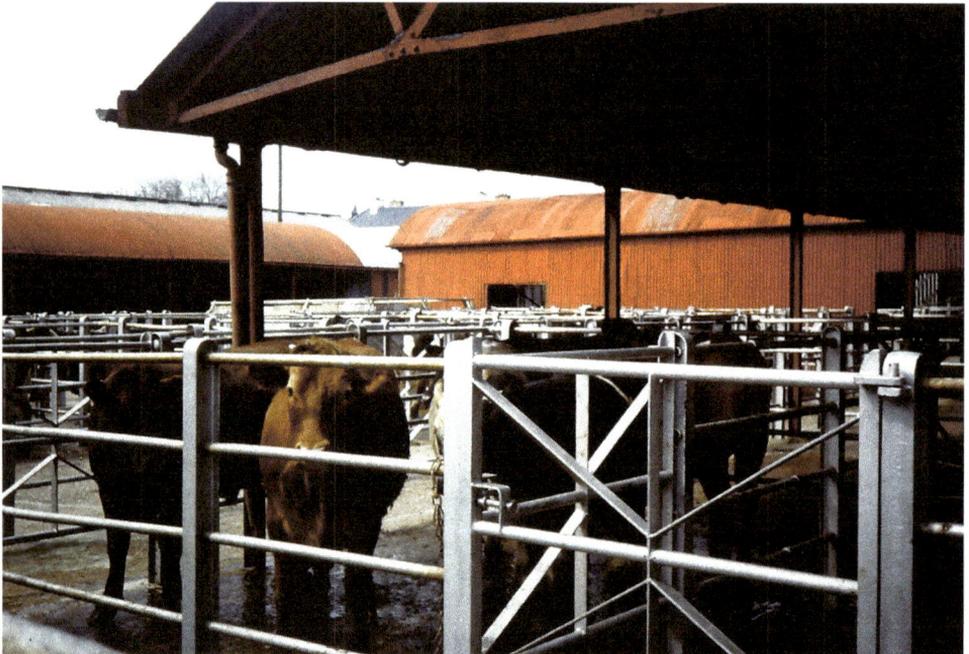

Newcastle's Cattle Market, which closed in 1994, when this photograph was taken.

Newcastle's Cattle Market.

The former Enderley Mills factory, Enderley Street, Newcastle, 2002.

At a time when more enlightened manufacturers were beginning to consider the advantages of factory planning to benefit both themselves and their workers – the Middleport Pottery (1888) near Burslem springs to mind – it is interesting to note that Stanway intended workers should not be troubled by having to climb flights of stairs. The design and organisation of the factory was enlightened and even egalitarian.

Referred to as a new army clothing works in the press, Enderley Mills became a limited company in 1883, with Stanway becoming managing director and retaining a substantial interest in the concern. It was certainly prospering by this time, supplying uniforms to the war office authorities, the yeomanry, volunteer commanding officers, railway companies and other public bodies.

That Enderley Mills was way ahead of its time can be seen from the glowing report given by W. D. Crump – Her Majesty's Inspector of Factories in 1884. He found that the regulations of the Factory Act were being scrupulously enforced, that it was clean and well-ventilated and that dangerous machinery was fenced off.

Beyond that, the working conditions were far more humanised than at other factories. At this time, the 700-plus hands had access to a large dining room, overseen by a committee of managers and workpeople. There was quality food sold at moderate prices, including meat and vegetables at 4*d*, soup at 1*d*, pudding at 1*d*, bread and butter or cake at 1*d* and tea or coffee for 1*d*. The kitchen was supervised by a matron, who gave lessons in cookery and household work to three or four different girls per week. The girls undertook kitchen work and were paid for it, and also received their food free of charge.

DID YOU KNOW?
Newcastle was a market town, surrounded by a large agricultural district. In 1871, a 'Monster Pig, alive and still growing' was exhibited in Market Place. Only twenty-four months old, it measured 11 feet long, 4.5 feet in height and weighed 200 stones, being 'calculated to grow to over One Ton'. The extraordinary animal was later exhibited in Chesterton and Silverdale.

Every employee at the mill contributed to a sick fund through paying a penny a week, with medicines being issued free from the factory surgery. A surgeon attended every day except for Saturday. At the time of Crump's inspection, a medical officer reported:

During the two years that the mills have been open only two deaths have occurred among the 700 employees, viz, one from typhoid fever and the other from smallpox, the cause of illness in both cases having its origin from a source quite independent of their employment at the mill. The majority of sick cases requiring treatment are those which are usually common among females between the ages of 15 and 30. It is worthy of notice that the cases of anaemia or poverty of blood bear a very small proportion.

This I attribute to the admirable management in the sewing-room as regards pure air, ventilation and light, and good and regular food in dining rooms.

There was also a crèche and nursery department. The crèche embraced two apartments that were used as a playroom and a cot room. The latter was fitted with cradles that, rather ingeniously, were gently rocked by steam machinery. Mothers were charged a shilling every week for each baby left in the crèche, with a matron looking after them. The mothers were permitted to visit the crèche for ten minutes in the morning and ten in the afternoon. Stanway went so far as to buy perambulators, hiring them out to the mothers at a moderate rate as an alternative to the arm-aching business of carrying the babies to and from work.

As of 22 April 1882, Enderley Mills had a branch office of the post office savings bank. Stanway offered to double the interest allowed by the government. His interest in co-operative practices appeared to know no bounds. He even struck a deal with certain tradesmen of the town to supply his workers at prices that would yield the lowest possible profit on the proviso that his workers should patronise those shops, which included grocers, drapers, shoemakers, jewellers, druggists and ironmongers. The discount given to Stanway's workers varied between 5 and 15 per cent.

Stanway also gave prizes for the best work of his employees as well as for their diligence. He also introduced opportunities for recreation, on the basis that some of the girls who worked at Enderley Mills were without friends in the town. So, in the evening, the dining room became a reading room stocked with books, newspapers and periodicals. However, if the girls wished to bring their sewing work with them or sing in the room this was permitted. This gave rise to the forming of a choir, who used the room for concerts. The singing and the piano-playing were done by the workers, with, it seems, very little supervision from management.

At the time of this inspection in 1884 Stanway had plans to provide baths, a garden, a recreation ground and model cottages for his workers.

The *Staffordshire Knot* praised Stanway's concern for workers' welfare, while the *Newcastle Guardian* was sufficiently impressed to record:

Whatever maybe said against the factory system, and the employment of married women in factories, surely it is far better for women and girls to be employed in such a clean, comfortable, light, healthy factory as this of Mr Stanway's than in the fever-sticken dens of the East-end of London...

The bankruptcy of Stanway in 1884 and the firm's subsequent takeover by John Hammond and the Company of Manchester opened up a fresh chapter in the history of the firm that is beyond the scope of this book. However, it is relevant to note that echoes of Stanway's welfare concessions were reported in the local press over many years, and among the references I can find are entertainments being organised for staff (1885), treats to the workpeople and a Christmas party (1893), a work function at the Bear Hotel (1914) and a sports club formed (1938).

Health and safety regulations in today's workplaces were implemented after many years of neglect by employers and the injury or deaths of countless workers in several hazardous industries. Take the death of Thomas Brindley, an engineman employed at the Cross Heath cotton factory in 1879. While assisting a blacksmith, who was cutting off a piece of iron from a bevel wheel, he was struck in the eye by a piece of metal that flew off from the wheel and injured badly. He continued to work for a further fifteen minutes, but when a second chipping flew off and cut his cheek, he ceased working. Being in great pain, he saw a surgeon the next day and was given some medicine. Sadly, he died shortly after, with the coroner's inquest concluding that the deceased died from the effects of morphia, or an overdose of it. It tells us much about nineteenth-century health and safety at work that the coroner's inquest concentrated on the accountability of the surgeon, Dr Edwards, and not the work-related incident that gave rise to this tragedy.

Even the previously mentioned Enderley Mills did not have an unblemished record in respect of avoidable accidents. It was there in 1914 that another fatality took place that could have been avoided if the management – Messrs Hammond & Co. – had shown a greater duty of care. Employee Archie Ray (aged twenty-five) was crushed when an electric lift, normally used as a goods lift, fell on him. The coroner declared at the inquest that although there was no evidence to explain how the deceased got under the lift, its ropes were undoubtedly damaged and the lift had not been shut off, notwithstanding the danger. Mr Moody, representing Ray, deposed that no notice had been put up and that the only way employees knew about it was by telling one another. Nevertheless, the jury's verdict was one of 'Accidental Death'. Ray was subsequently buried in Hanley Cemetery.

Anyone who has trawled the nineteenth-century newspapers knows that mining accidents and fatalities were numerous, though the nature of some of them could occasionally be bizarre. Take the case of Thomas Galley, who was killed at the White Barn Colliery in Chesterton in 1861. Thomas was a hooker-on at the pit and had descended the shaft as usual, though, two hours later, he had taken it upon himself to ascend again to 'see what sort of weather it was'. Bear in mind that in those days miners travelled up and down the shafts by means of crude chains. Thomas lost his grip and plummeted 100 yards down the shaft to his death – all because of a little idle curiosity.

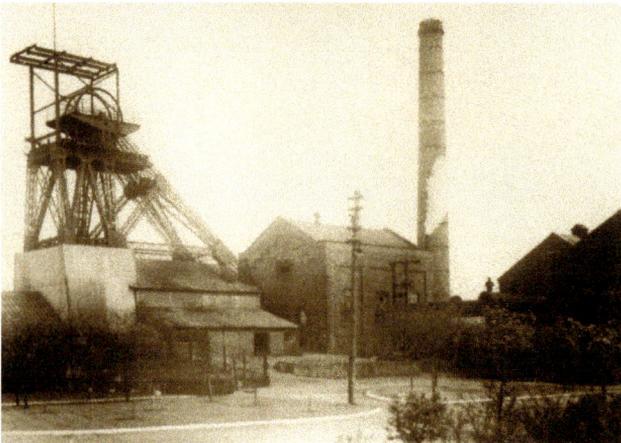

Parkhouse Colliery, Chesterton probably 1940s. It closed in 1968 and the Parkhouse industrial estate was built on site.

Particularly sad was the demise of Thomas Brown in 1870 at the Apedale Works. He was talking to a workmate while filling a mine when he fell down the shaft and died shortly afterwards. By nineteenth-century standards this might sound like a routine fatality in a coal mine. However, it was reported that this gentleman had fought for king and country ten years before the Battle of Waterloo. He had taken part in that glorious campaign and had served the army for years afterwards. How tragic that this old soldier should have died in a coal pit at the age of eighty-three.

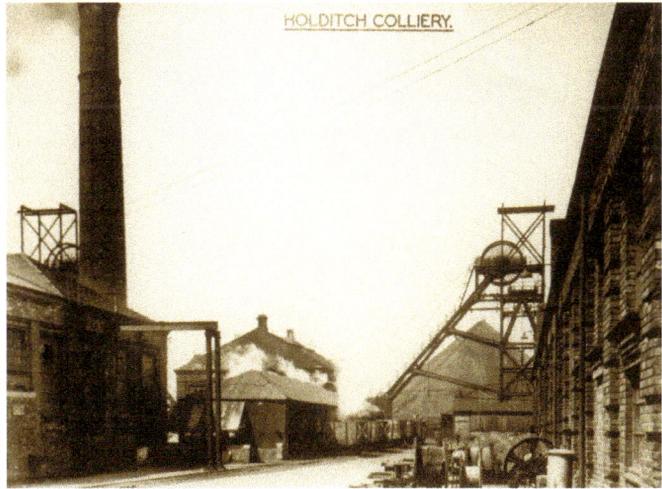

Right: Holditch Colliery, Chesterton, probably in the 1940s. It closed in 1989.

Below: Holditch Colliery, Chesterton. Ragman 21s workings, 1966.

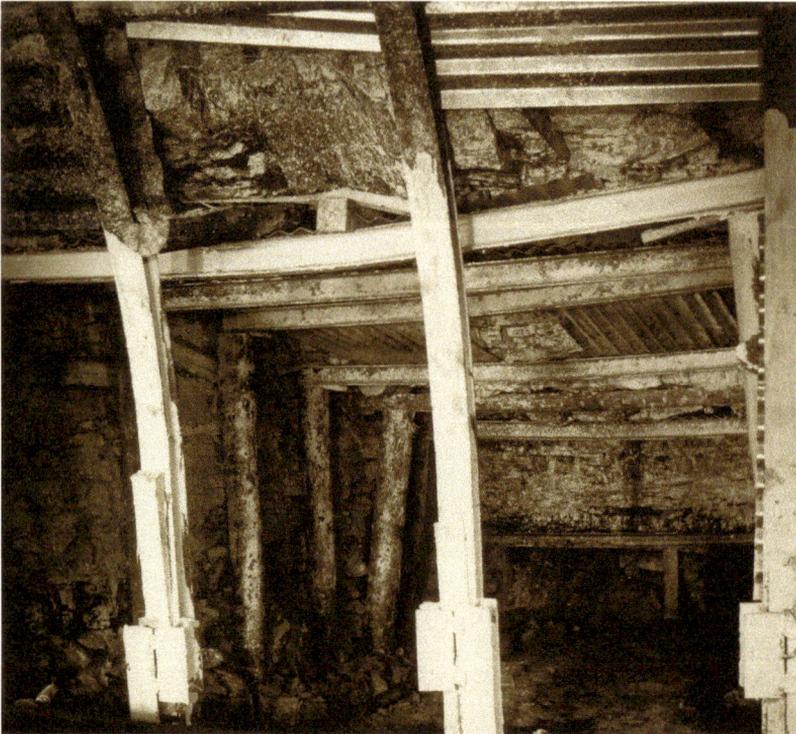

Above and left:
Holditch Colliery.

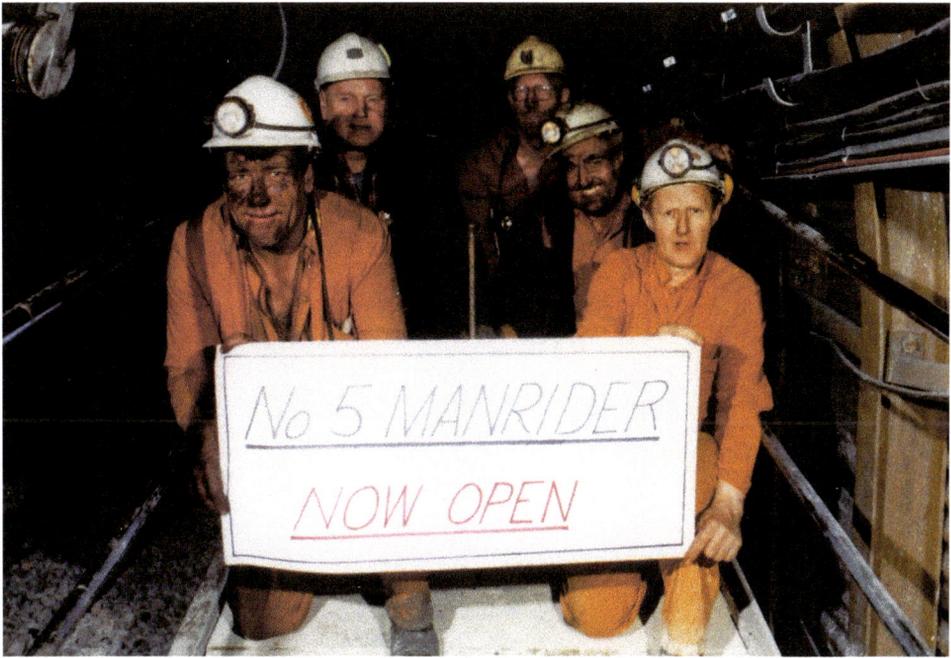

Holditch Colliery miners, 1985. Nobby Clarke is second from right.

Heavy industry brought jobs and prosperity to many areas, though this came at a price. Part of that price was subsidence – the tumbling down of buildings, and pot-holed roads. It didn't take long for mining subsidence to become a major issue following the sinking of Wolstanton Colliery – you can find many interesting references to discussions on this matter in the local press and in the minute books of Newcastle Town Council.

The council found, certainly by 1935, that damage to property through mining subsidence was increasing in Wolstanton and its environs, and it was predicted that the damage would only increase as the pit continued to mine the rich seams available. It was claimed that in some cases property that had been purchased through life savings had been damaged, as well as streets, water and gas mains. Compensation arrangements were advocated for property owners, and the Duke of Lancaster – who owned most of the land in question – was interviewed with a view towards concessions being made. One council minutes referred to some houses that were 'not entirely unfit for habitation' but which were 'suffering severely from defects due to mining subsidence'. In 1938 one property at the junction of Lily Street and High Street was so damaged by subsidence that it required shoring up; however, the colliery company denied responsibility after being challenged by the town clerk of Newcastle.

Meanwhile, the Wolstanton Traders' Association began to air their grievances over subsidence. One of them, W. A. Knowles, complained of how traders and local houseowners were having to spend thousands on property repairs. It was reported in the press that both Ellison Street School and Watlands School had been affected by subsidence.

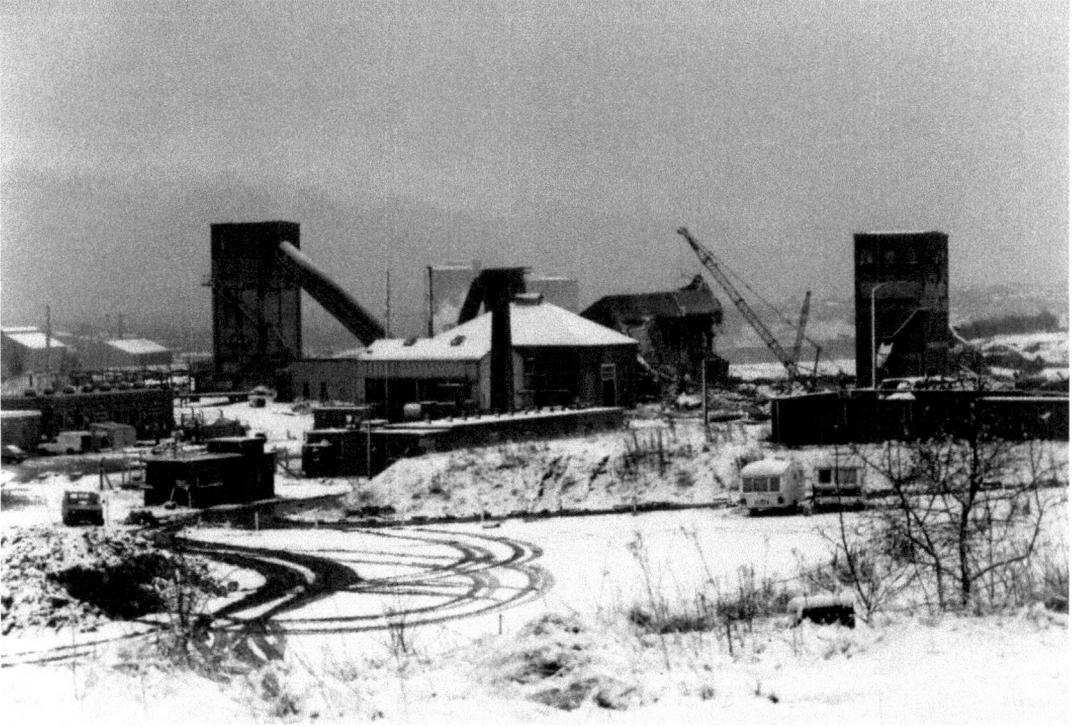

Wolstanton Colliery in snow, probably 1970s. The colliery closed in 1985.

Until 1943, it was the custom for the Wolstanton Colliery Co. to let down the surface of land without payment of compensation. However, in that year Newcastle Council fought a test case, and the custom was held to be unreasonable. A subsequent order was made through the House of Lords providing for payment of compensation by the colliery for subsidence damage and depreciation of property. It proved to be a landmark case in Wolstanton. Subsidence and accountability continued to be a pressing issue for many years to come – especially with the inevitable expansion of the colliery.

We have seen in this chapter how industry had a diverse impact on the landscape and communities, but we shall end it by recollecting how, back in 1835, it was instrumental in putting the fear of God into some people.

The *Staffordshire Mercury* reported that many Hanley people were greatly agitated over an unearthly, unexplained moaning and rumbling sound. The newspaper, taking its cue from various correspondents, described the unaccountable noise as a deep, hollow moan of distress – something like the gasp of expiring nature. Halley's comet was gradually making its way across the night sky at this time – August/September 1835 – and there had been much talk among the superstitious people of Hanley and elsewhere that the comet and the unearthly groaning might be some harbinger of Doomsday. There was no need for this hysteria as the people of Hanley were soon to hear an explanation. A correspondent wrote to the newspaper and told that he had gone out on the previous Sunday morning and heard this strange noise, which he described as being like the bellowing of an

enraged bull. It grew louder as he made his way out of Etruria, through Wolstanton and into Chesterton, where he asked a local what the noise was. The man replied that this was the sound of the blast produced by a new engine at Apedale Furnaces – the awful noise having been borne on the wind and across the valley to Hanley. It was not, therefore, some omen that the world was about to end, and everyone was able to sleep peacefully in their beds once more!

DID YOU KNOW?

Ralph Lewis was an engine tenter at the Glasshouse Colliery in Chesterton. In 1876, following a drunken spree, he was found hanging by his clothing from a piece of wood in the mouth of the pit shaft at the colliery. It was unclear whether he had got there by accident or whether this was a suicide attempt, but, upon being rescued from his perilous position, he was found to be so drunk that he had to be taken home in a wheelbarrow.

3. Houses and Homes

Some fine old houses in Newcastle managed to survive through change of use, as in the case of the Beeches in Liverpool Road. Sales notices relating to this property underline its desirability. There was a bowling and croquet lawn attached at the time of its sale by auction in 1871, as well as conservatories, pleasure grounds, walled gardens, stabling and coach houses, while the home itself embraced a drawing room, dining room, breakfast room, library, kitchen, butler's pantry, laundry and bedrooms.

Garden Street, Newcastle, date unknown.

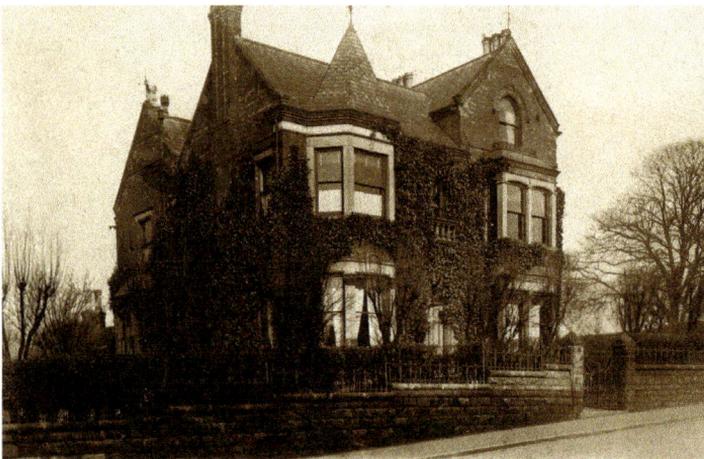

King Street, Newcastle, date unknown.

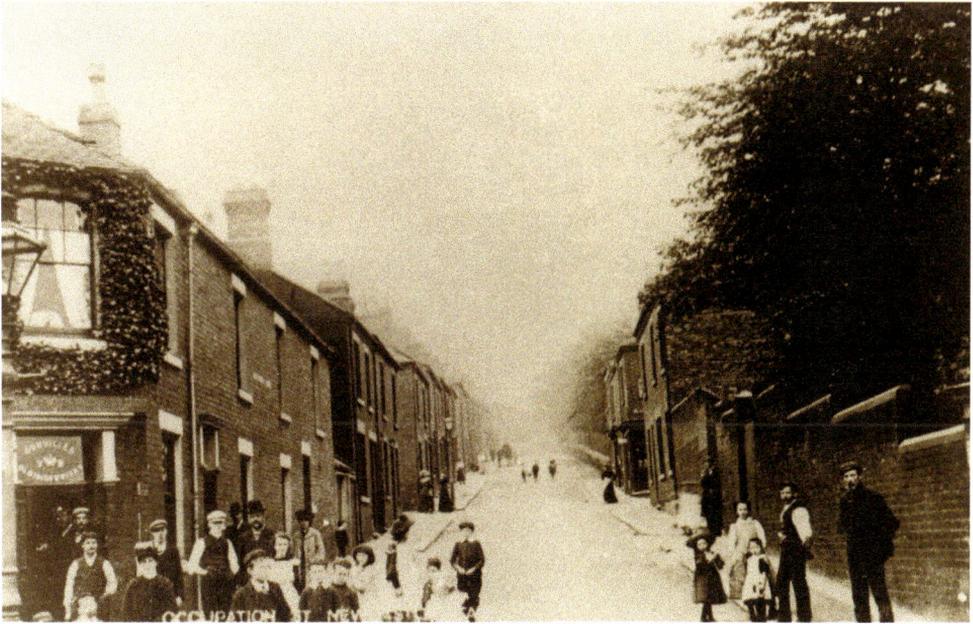

Occupation Street, Newcastle, date unknown.

When up for sale in 1914, the spacious house could also boast of vineries, stove and fern houses, tennis courts and a small paddock. The house and grounds, then in the possession of the notable Mellard family, would have constituted an attractive proposition, though no one in 1914 could have foreseen what would ultimately happen to the property. Its location, on the main road from London to the north, made it particularly suitable for Newcastle's new bus depot and garage. In January 1931 the Potteries Electric Traction Company bought the site – over 3 acres in extent – and opened its new facility in 1932. A garage was built to accommodate sixty-six buses and the Beeches itself was transformed into offices, a restaurant and a restroom for long-distance passengers. As such, a dignified old property played its part in consolidating Newcastle's reputation as a transport hub of North Staffordshire.

Another fine building in Merrial Street, the former Conservative Club, was once two homes: Wilton House, which was occupied by well-known builder Samuel Wilton, and Hawthorne House, which was occupied by a bachelor named Josiah Wedgwood. The club was formed in 1868 and became proprietor of the two buildings in 1875. The front gardens were replanted and fenced in 1890.

Other old properties found new uses too, such as the Cloughs. The historian John Ward, writing around 1840, described it as the mansion of Revd John Basnet and situated on Keele Road. However, it is described as a 'Home for Feeble Minded' in *Kelly's Directory* of 1928. Such institutions were often visited at Christmastime by civic dignitaries, as we read in 1930, when the Lord and Lady Mayoress of Stoke-on-Trent called at the Cloughs Institution and inspected the wards and dormitories. There was also a visit from a member of the Mental Health Deficiency Committee.

Much has been written in the past about workers' houses, with prominence given to the story of the Wedgwood employees' dwellings in Etruria or the Minton Cottages in Hartshill, but one lesser-known scheme over the Newcastle border deserves a mention in this book.

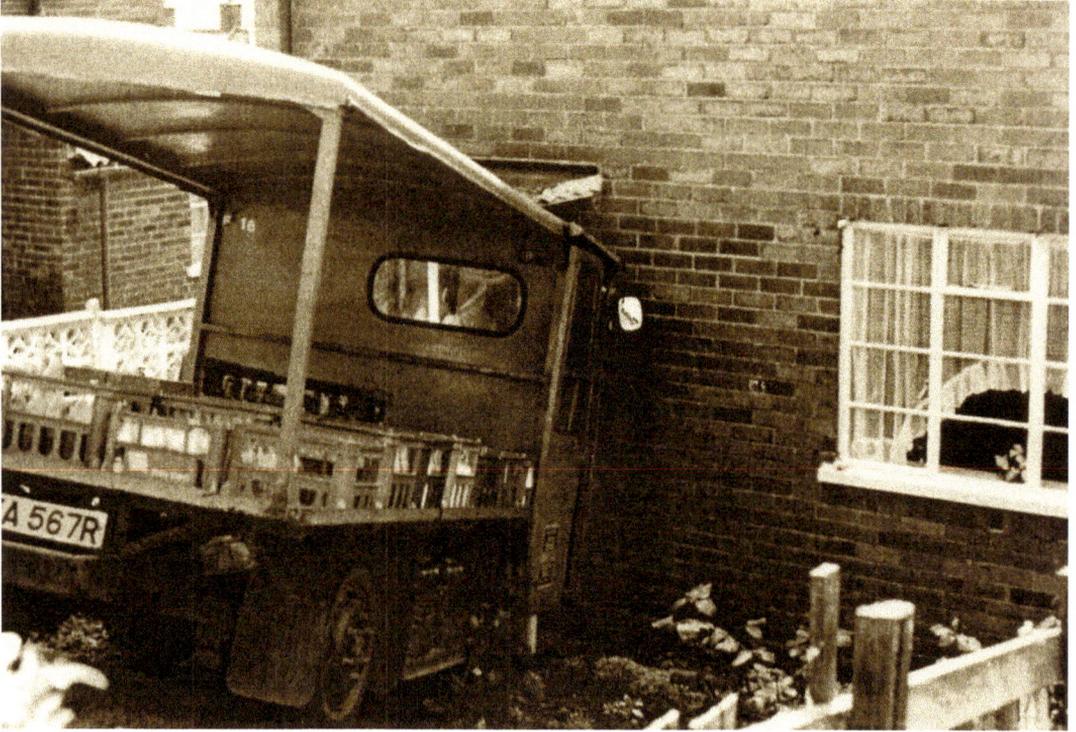

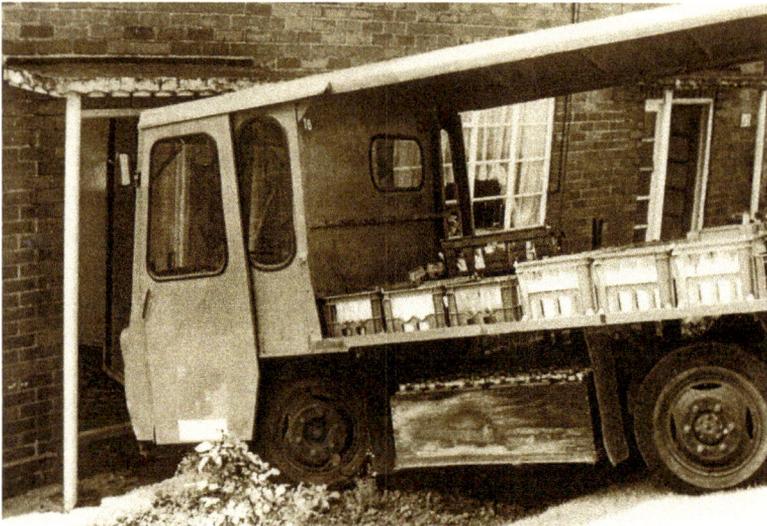

A milk float crashes into No. 65 Romney Avenue, Chesterton, c. 1985. The picture was taken for insurance reasons.

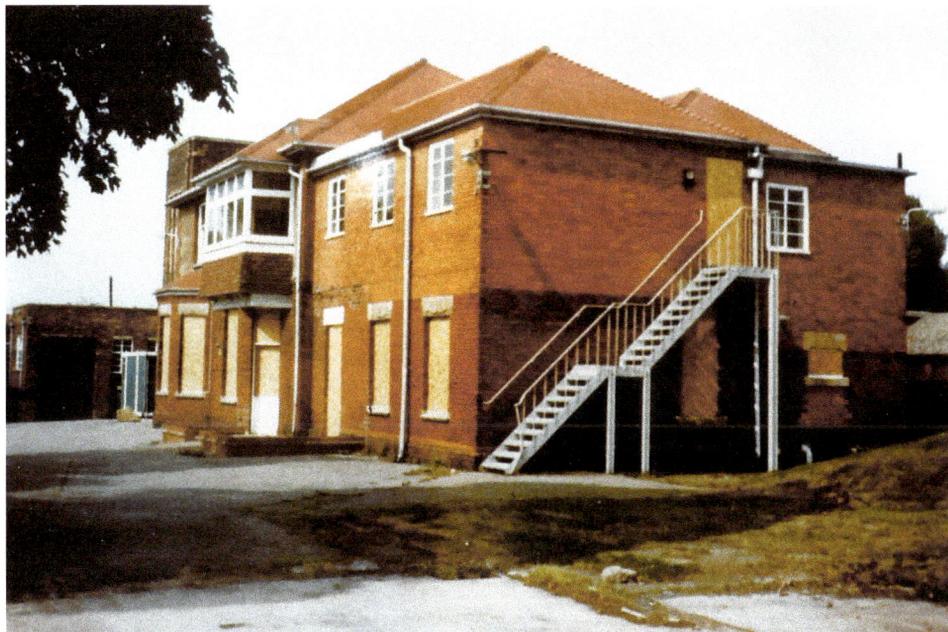

The former Fanny Deakin Maternity Hospital in Beasley Avenue, Chesterton, was once a private house named Farcroft. Newcastle councillor Fanny Deakin lived in Silverdale all her life. This image was taken in 1991.

If you look at these terraced houses along Moreton Parade, you will see another example of how developments across the Fowlea Valley influenced the construction of May Bank and Wolstanton from the second half of the nineteenth century. There is a white-painted tablet on one of these houses. Although the inscription on it has weathered very badly, it tells us that the houses – originally described as 'model cottages' – were built by the British Steel Smelters' (Trades) Union. The tablet was unveiled on 24 September 1904 as 'An Effort to Solve the Housing Problem'.

DID YOU KNOW?
Some Newcastilians will recall that the Almshouses in Bridge Street, built in 1743 for twenty poor widows of the town, were demolished in 1964. However, their demise was a long time in coming. As long ago as 1938, the press reported that they were to be demolished to make way for road improvements.

The British Steel Smelters' Mill, Iron and Tinplate Workers' Association was a society that had been formed in Glasgow in 1886. It quickly set about raising funds for the welfare of members and was so successful that it was able to build workers' housing in two other

Moreton House, Wolstanton, 1994. Once a private home, built in 1743, the building was taken down – brick by brick – and its frontage reassembled by 1980. Flats belonging to the Staffordshire Housing Association were built behind the façade.

Moreton Parade, former steel smelters' houses, 1994.

parts of the country before turning its attention to May Bank. Twenty-one houses – in three blocks – were erected overlooking May Bank Marsh. The cost was £8,000.

Ostensibly, the properties were built as a response to the lack of working-class houses in the area, but they also represented the growing strength of working-class political and co-operative movements, and were very much an ornament to the village of May Bank. Here was a trade union flexing its muscles and wanting the area to know all about it. The houses were a statement in brick and mortar of what a trade union might achieve.

The three-bedroom houses were built of Accrington brick and had garden forecourts. They were the fruits of local labour, with the architect being F. R. Lawson of Fenton and the builder Stephen Heath of Basford. The cottages would be let to certain members of the two local branches of the society established at Shelton Bar, and remained the common property of that society.

Newcastle's first council houses were built in 1915 and were, appropriately enough, called the Corporation Cottages. They were made possible by the provisions of the Housing of the Working Classes Act (1890) and may be seen as a groundbreaking social enterprise for their time. Reports of town council meetings in Newcastle, in respect of the initiative to provide workmen's dwellings in the town, provide a great deal of background information. There had been a recognition for some time that much working-class housing in the town was inadequate, hence the demolition of insanitary property and slum cottages in the Lower Green area. By 1914 it was planned to erect twenty-nine dwellings to be let at various rentals in Lower Green, Castle Hill Road and Stanier Street. Private enterprise, it was asserted, had failed altogether to meet the need for working-class houses. Indeed, there was such a shortage of these dwellings that it had been necessary to leave many unhealthy, overcrowded houses standing until the new houses had been built. The sanitary inspector submitted that there were probably around half a dozen cases of two or three families living in one house, causing much overcrowding. John Mayer, a bricklayer, Chairman of the Housing Committee and vigorous advocate of the Corporation Cottages scheme, related a case in which a widow and three children lived in a house containing three bedrooms. First a daughter was married, but being unable to find a house came to live with her mother, along with her new husband. The son then married and did the same thing, hence acute overcrowding in one property. The demand for workmen's houses was, it was stated, created by the number of colliers and ironworkers in the area – and with the colliers on 'good wages' it was envisaged that they would not fall behind on rent payments.

Also interesting are perceptions at this time in relation to the type of house interior required by the working man. Though the new houses were planned to have one good living room, a scullery and out-houses, they were not intended to be built with a parlour – which, it was said, was never used unless there was a funeral or a wedding. This comment drew laughter at the town council meeting in August 1914, but not everyone was inclined to be amused. Mr Mason, the owner of sixteen cottages in Stanier Street, opposed the scheme, stating that if the planned properties were not to have parlours, then they would be of a lower standard than his own houses and bring down their value. There may have been an element of social snobbery in Mason's arguments, as he foresaw that the parlour-free corporation dwellings would see people living in the front of their houses

with their doors wide open, and 'it would be a play-place'. Mr Mayer dismissed such arguments, asseverating that the cottages proposed to be built were of better quality than Mason's houses with considerably more frontage.

These proposals were reported at length in the *Staffordshire Advertise*, which, in an editorial column, offered a teasing question for the contemplation of its readers: 'Is the working-man's parlour doomed? And if so, will he be better off without it?'

The twenty-nine Corporation Cottages were duly built in 1915, replacing sixty-five old buildings on site and representing the beginnings of municipal housing in Newcastle.

The first residents of the new Crackley residential estate at Chesterton moved in during 1954. With the estate having been built on the site of old fields and farms, it should not, perhaps, have come as a surprise that many of the new properties would be infested

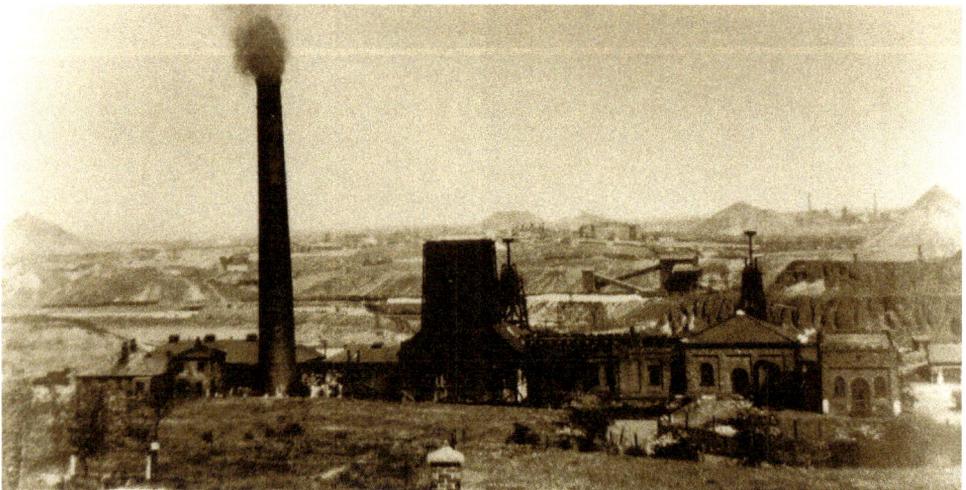

Houses in May Bank suffered from industrial pollution created by heavy industry. Here is Wolstanton Colliery in 1948.

Cherry Tree Road, Chesterton, 1994. Note the gorilla in the front garden.

with insects. It was reported in 1961 that Maple Avenue had been plagued with an earwig colony for two or three summers past, with the insects getting into people's houses, food and beds. Residents complained to the local press. Mrs Sarah Gilbert, of No. 23 Maple Avenue, declared, 'It's shocking here for earwigs. The house and garden are full of them in the summer. When you get up in the morning and draw the curtains they drop on to you – it's horrible.' She was apparently told by the council that they were a garden pest and there was nothing that could be done about them. Mr Josiah Cook, of No. 54 Whitethorne Way, complained he had to strip the clothes off his and his child's bed every evening before they retired for the night to get rid of the pests.

One particular house on the Crackley estate is remembered by some as being a real eyebrow-raiser. The property, in Cherry Tree Road, belonged to Karl and Pat Johnson. Karl had been employed as a miner, but had suffered an accident at Wolstanton Colliery. He had considerable artistic talent and decided to adorn his garden with sculptures. If you looked over the privet you would see a Viking warrior poised to strike with his double-headed axe. He was flanked by a horse with a flying mane and a muscled man brandishing a sword. There was also a Roman gladiator clutching a net and trident, as well as a large gorilla. For extra effect, there were oversized butterflies – all of them were made by Karl using steel rods, chicken wire and concrete.

Lastly, a reminder that some people did not have a permanent home – neither did they seek one. In 1869 gypsies from Epping Forest made camp on a field at Friar's Wood, near to the Sutherland Arms in Newcastle. The company numbered around twenty people, all living in five travelling caravans. It was understood that they were descendants of

ancient gypsy tribes. It was recorded in the *Staffordshire Weekly Times:* 'The most reliable historical records of their race say that they appeared in Paris as far back as the year 1427.' Perhaps this is why Newcastle welcomed them so warmly. Two balls were held in their honour – at the Guildhall and the Covered Market – and were attended by the gentry and businessmen of the neighbourhood. Quadrille bands played for dancing and hundreds of townspeople swarmed to the Guildhall to try and catch a glimpse of the gypsy king and queen entering the building.

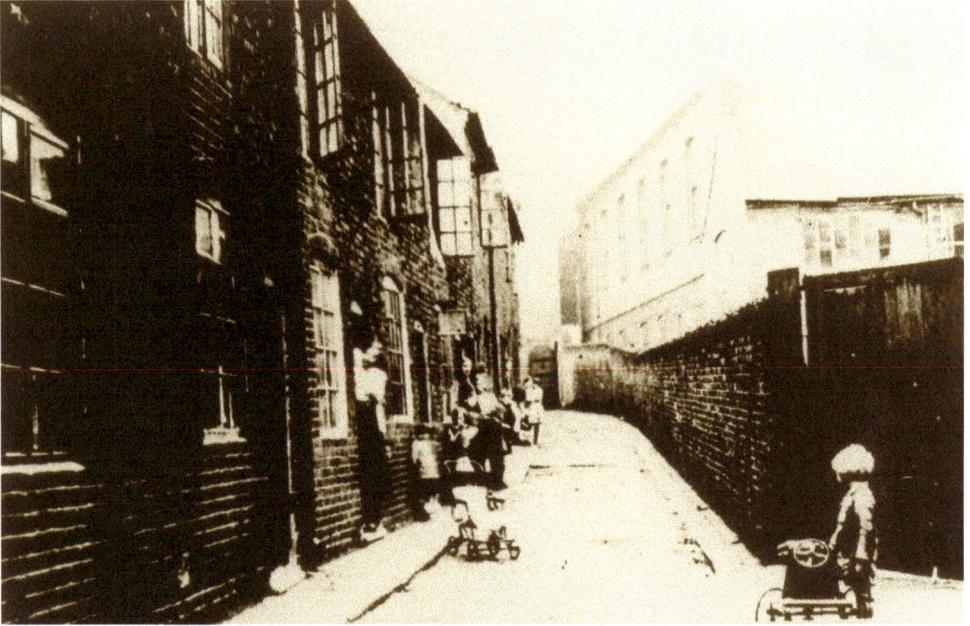

Above: Ball's Yard, Newcastle, early twentieth century, showing primitive living conditions.

Left: Hart Street, Newcastle, showing backs of houses, 1955.

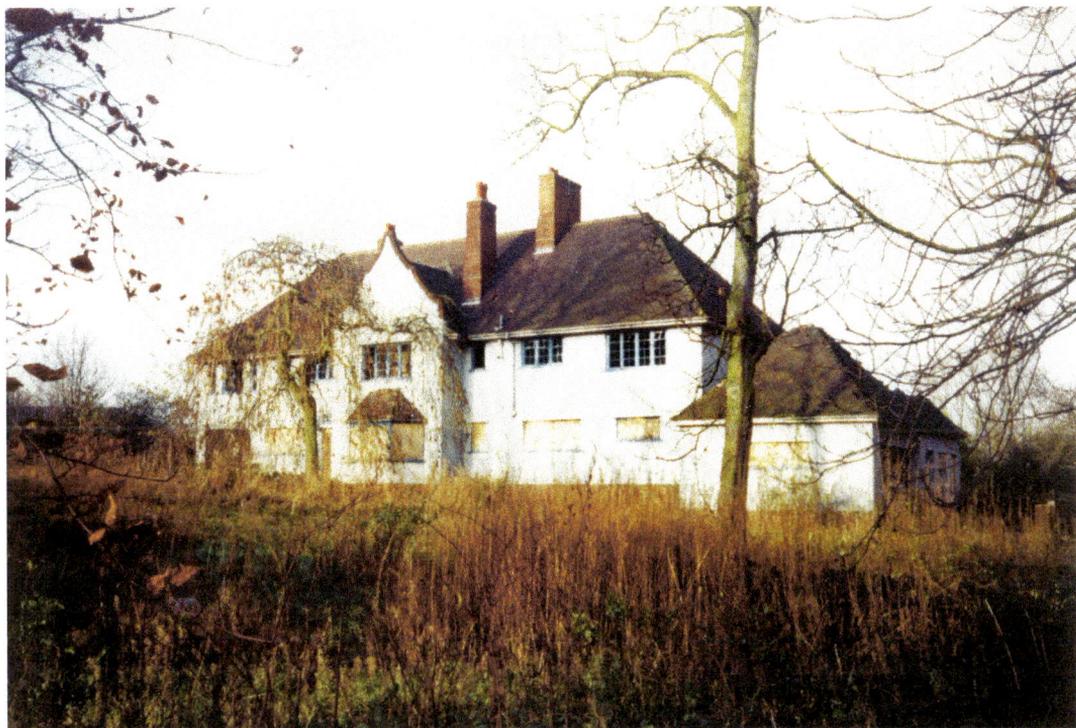

Mayfield Court, the Brampton, 1991.

DID YOU KNOW?

A blue heritage plaque on the front of Moreton House in Wolstanton tells us that it was the former home of the eminent scientist Oliver Lodge (1851–1940). He reminisced about the old house in 1928, when he officially opened Wolstanton County Grammar School, recalling that as a young man he had educated himself in the outhouses of the house. He added that his father had rented it and that he (Lodge Jr) had used the attached barns, cow-houses, breweries and dairies as laboratories, thereby learning the rudiments of physics.

4. Health

Public health and sanitary arrangements were weighty matters in early nineteenth-century Newcastle, not least because many people died of cholera, as we are reminded by the following memorial inscription in St George's Churchyard:

SACRED

TO THE MEMORY OF

JOHN TOMKINSON

Who died August 8th, 1849

Aged 75 Years.

Also of MARTHA Relict

Of the above, died August 18th, 1849

Aged 69 Years

They fell Victim to the Asiatic Cholera.

Be still and know that I am God:

Psalm 16th, Verse 10th.

Outbreaks were particularly virulent in 1832 and 1848–9, with efforts to combat it hampered appreciably by uncertainty about how it was spread. It was not until it was confirmed that cholera was primarily a waterborne disease, and that effective methods of fighting it through better sanitation were required, that it became less of a threat. However, until the mid-nineteenth century, the spread of cholera was blamed on various possible causes: from miasmic mists emanating from cesspools and graves to the allegedly filthy habits of Irish immigrants in the town.

This uncertainty gave certain agencies the opportunity to brainwash frightened and vulnerable townsfolk, and in 1832 the Rector of Newcastle set aside 31 August as a day of humiliation and prayer for parishioners. The measure was rubber-stamped by the bishop of the diocese, with services taking place at both St Giles' and St George's churches in the town. It is an indication of the influence of the Church at the time that 'all the shops were closed, and the greatest quiet prevailed throughout,' though we should add that the different Dissenting chapels were also open through the day. However, the improvement and better management of drains was a long time coming, triggering many health hazards.

A remarkable case in 1871 related to the open state of that section of the Lyme brook that ran from the Holborn, by the paper mill, to what was once Pool side. This stretch of water became increasingly filthy and dangerous to local people, especially when they were passing to and from their homes in darkness. It was noted in the press that at the Pool side the shallow waters of the brook entered a culvert of 2 feet in diameter where

the water current was strong. The mouth of the culvert was unprotected. A five-year-old boy who lived nearby fell into the brook and the current drew him into the culvert. Some other children informed the boy's mother and she ran to the spot to find that there was no sign of him. Though despairing, she had the wit to run to the other end of the culvert, which ran underneath the gardens of the Pool dam and to Stanier & Company's coal wharf – a distance of 300 or 400 yards. She told one of the men at the wharf what had happened, and they ran to the mouth of the culvert just in time to catch the boy who had been carried through.

'A moment later', reported the *Staffordshire Weekly Times*, 'and he would have been borne underneath the Pool dam road, and hurled down the fall on the other side'. Though partially unconscious, confused and drenched, the child survived, his narrow escape being a reminder to the authorities of the need to protect the public from such dangerous spots.

DID YOU KNOW?

The sheer range of – sometimes questionable – cures sold by our chemists of yesteryear is underlined by an item described as the discovery of the age by Poole's chemist in Newcastle, in 1886. 'Poole's Titthoterapeuticon Or Nipple Healer' was claimed to have been successful in curing the cracked or sore nipples suffered by ladies during periods of nursing.

The cry of 'water, water everywhere, and not a drop to drink', may have rung true in certain parts of the borough of Newcastle, for Adam's ale was not always potable.

The public requirement for well water endured up to the 1870s and later. It was reported in 1878 that notices had been served on James Pointon and James Platt for closing wells belonging to them in James Street, Wolstanton. However, the well water had been described as being unfit for use and, by this time, tentative arrangements were being made with the Potteries Waterworks Company for the supply of taps. In the same year, a sample of water from another well – in Lily Street, Wolstanton, belonging to a Mr Baggaley – was found by a public analyst to be unfit for human use. Such reports tell us much about the slow rate of progress made by the various authorities in providing basic amenities and the potential danger that some well water posed to public health.

Certain areas of the town continued to be insalubrious even if they were not particularly hazardous. At a meeting of Stoke Town Council in 1874, Councillor Kirkham referred to the Lyme Brook and the Newcastle sewage tanks, which he described as a series of cesspools, the stench of which was obnoxious, even in the winter months. It was reported that sewage from Knutton and Apedale discharged into it, as well as from Silverdale. The Lyme brook was only a few yards from the highway (the present A34) and near to Stoke workhouse, where, according to Mr Kirkham, fever was almost chronic.

Fortunately, there were members of the medical profession well qualified to deal with ailing members of the public – and some who were not. Let us consider an odd story from

1847. The *Staffordshire Mercury* reported that, around two and a half years previously, there had been a sensation in Newcastle through the apprehension of a travelling quack doctor and his wife. They had earned a pretty penny by convincing a gullible public that they could cure every disease that flesh was heir to. The woman, who purported to be 'deaf and dumb', practised as a clairvoyant and was in the habit of predicting 'good husbands and soon' for many blushing maidens or robust widows.

The couple had stayed at the Crown Inn in Newcastle for three months, where their ramshackle old caravan was also accommodated. The old husband barely left the house each day, enjoying beer and a pipe while his afflicted wife walked to neighbouring villages and did not return until evening. Newcastle's police superintendent, Isaac Cotterill, began to take an interest in this couple and how they made their livelihood. He therefore became more vigilant concerning goings-on at the Crown.

DID YOU KNOW?

A press report from 1863, entitled 'Dr Brown again', refers to a medical gentlemen living in Silverdale. He was charged with being intoxicated in St Luke's Church and refusing to leave the place of worship. One witness testified that Brown was throwing his arms around in a very wild manner and annoying the congregation. We find another reference to Brown in 1875. He was described as a surgeon and again up before the courts, where he was found guilty of drunk and riotous behaviour.

Cotterill's vigilance paid dividends. One day, upon returning from her rounds, the woman over-indulged in liquor and became appreciably intoxicated. A quarrel ensued between man and wife, and the domestics at the Crown overheard it, discovering that the lady was certainly not deaf or mute. Cotterill intervened and found in their cart a quantity of plate and other valuable goods 'with the large sum of £341 18s 6d in the current coin of the realm'. The impostors subsequently appeared before the borough magistrates, but, as none of their collected items could be identified as stolen, no criminal charges were made and the couple were released on the promise that they would leave town. The defendant – who, according to handbills on his cart, practised under the name of 'Dr John Kitchen' – left Newcastle with his spouse, now happily restored to speech. However, in October, 1847, the *Staffordshire Mercury* told that 'Dr Kitchen' – under another name – was brought before the magistrates at Lambeth police office. The London newspapers reported that John Wild, aged eighty-two, who was exceedingly corpulent and wearing ragged clothing, had been charged with drunkenness, and had in his possession a tray of silver plate, eight watches, articles of gold and a cotton bag containing 280 sovereigns. The court heard that nearly three years after his antics in Newcastle, he was still in the habit of travelling around the country with a horse and cart, professing to cure the 'deaf and dumb'.

The interiors of many houses in Newcastle boasted coal fires – remembered by many people today with nostalgic affection. We conveniently forget that they created much

smoke and coal dust. In the nineteenth century, the accumulated soot in some chimneys posed health hazards. Sadly, the workers tasked to address the problem were exposed to the most pernicious conditions themselves – we refer to chimney sweeps' climbing boys.

Many shocking acts of cruelty occurred. The *Staffordshire Mercury* conveyed in 1833 that one climbing boy had been instructed by his master – his own half-brother – to clean the chimney in Hicks Street, Newcastle, a few yards from his own home. The six-year-old boy duly climbed up part of the chimney, but then ceased. He was asked what he was doing and replied that the width of the chimney was preventing him from making further progress by supporting his back and knees. The sweep ordered him to climb further or he would burn him. The child responded, 'You can't hurt me, for I'll creep in a corner.' The man then set some straw on fire, its smoke and heat persuading the boy to descend, even as his master piled more straw on to the fire. Dreadfully scorched and almost suffocating, the child fell into the burning mass beneath 'and was so much injured that it is doubtful if his life can be preserved'. The matter went to court and magistrates heard that the act of cruelty was all the more unacceptable on the basis that when the sweep himself had been a youth, he had been kindly treated and received some education from benevolent individuals. Questions were also raised about those people who permitted the crime to be committed in their house.

However, the need of property owners to keep their houses free of chimney soot effectively kept sweeps in work for many years – even after machines had been introduced to do the jobs of chimney boys. In 1859 James Moss of Newcastle was charged with sending a boy up a chimney instead of using his machines to clear them out. The trouble was that many houseowners believed that the machines made more mess than the boys, hence the old practices occasionally continued in spite of new legislation.

Another case, in 1870, saw James Bloor and householder William Rhodes being charged by the police. Bloor's son, aged eight, had been seen by police constable Deakin coming out of the house with a long sweeper's cap over his head, and with trousers worn around the knees. He had been up the chimney, while Bloor's machine was outside the door, never having been used. The magistrates' court heard that the boy had ascended four chimneys in Lower Street. Rhodes, who claimed not to know that the law was being violated, was let off with payment of costs, though Bloor was heavily fined.

'Smuts' were certainly a problem in the Potteries. The air quality in industrial Stoke-on-Trent was widely accepted as a threat to public health, but it is now largely forgotten that Newcastle was not without a few similar issues.

DID YOU KNOW?

An annual pageant and flower day was held in order to raise funds for the Wolstanton Nursing Association. The procession through the village was a highlight of the year. Among the groups and bodies processing in 1927 were the Wolstanton Fire Brigade, the Norton Brass Band, the Talke Morris Dancers and numerous local residents in fancy dress. Even the Potteries Electric Tramway Company contributed, touring the streets with a barrel organ and a monkey.

Wolstanton Colliery provided many jobs in the village, but at a price to local residents: smoke belched out of the colliery chimney. In 1930 Porthill Park Cricket Club complained to the local health committee that smoke from the colliery was disturbing the players and spectators during their matches, which were held on the other side of Wolstanton Marsh.

However, the colliery was not the only pollutant to disturb the peace at May Bank, for residents lived a relatively short distance from the local ironworks and steelworks in Etruria – 'Shelton Bar'. By the late 1950s, this issue had been brought to the attention of the local press. Dust and soot was wafting over the Stoke/Newcastle border and smothering homes in Catherine, Kelvin and Clifton Street, May Bank. Residents drew up a petition and asked Newcastle MP Stephen Swingler to take action. Mr Whittaker of Kelvin Street provided two bottles of soot as evidence, which he claimed his wife had collected off a window in just one day. Dirt not only settled on windows, but also on window sills, doors and clean washing hung out to dry. One neighbour even complained that the grime clung to the paintwork inside her house and referred to the tiny airborne pieces of steel dust that were a danger to the eyes – all of which was an indication that the Potteries, which was historically infamous for its grimy skies, was more than happy to share its atmospheric pollution with its neighbour, Newcastle.

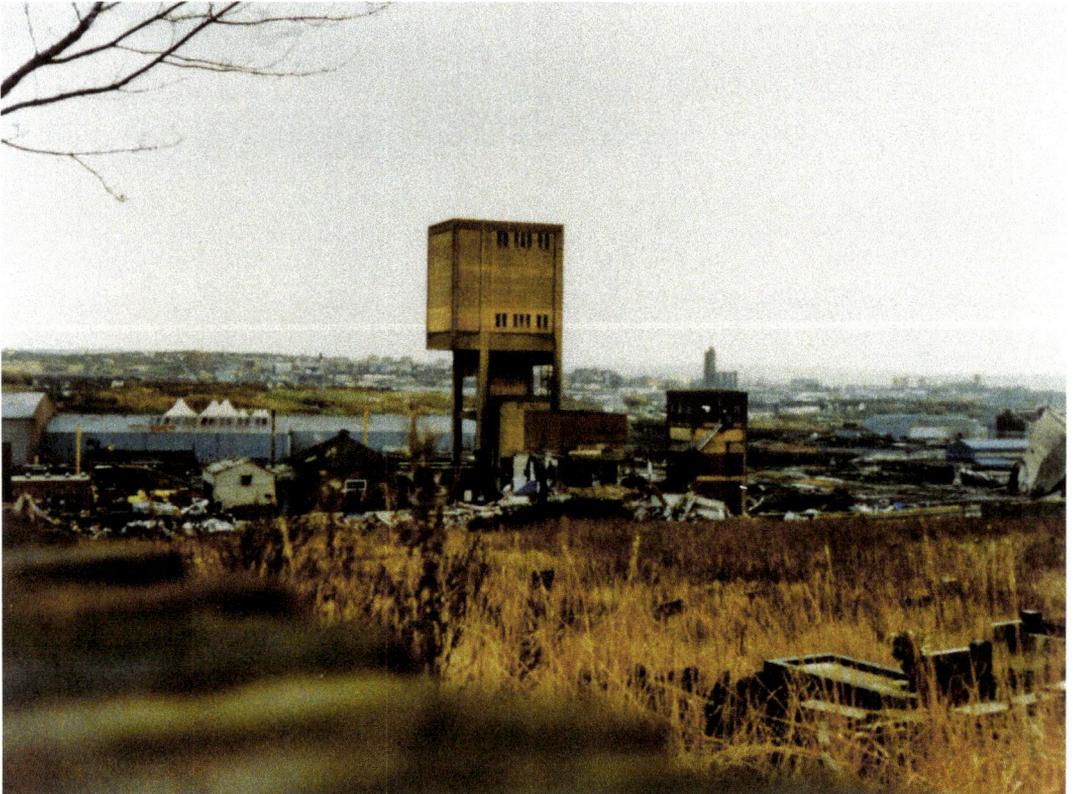

Wolstanton Colliery during demolition in 1987.

Shelton Bar in the 1960s. (Courtesy of Ewart Morris)

Merrial Street toilets, Newcastle, 1994. They have since closed.

5. Local Government and Public Services

Throughout Newcastle's history, residents have clung hard to the past and opposed the removal or demolition of much-loved landmarks. We think of the Castle Hotel, the Municipal Hall and the old St Giles' and St George's school behind Queen's Gardens, not to mention the controversy over plans to scrap the town's Crimean War cannon as mentioned in chapter nine. Some Newcastilians felt equally aggrieved back in the 1870s when it was then proposed to consign a faithful old town amenity to the past. So let us describe the controversy of the Butchery Pump.

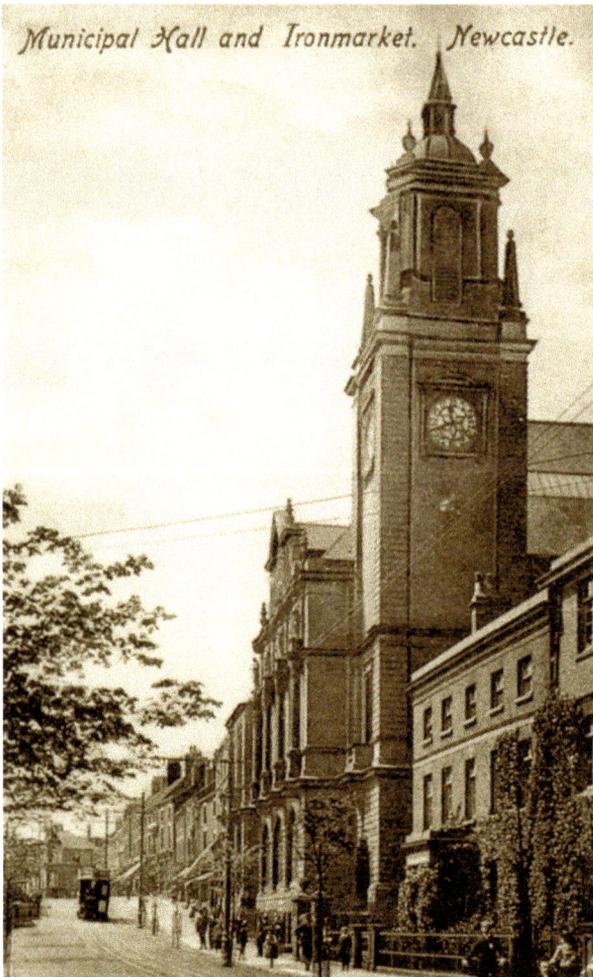

Municipal Hall, Ironmarket, date unknown.

Guildhall, Newcastle, 1996.

Thanks to sanitary improvements and benefits brought to the town by the Staffordshire Potteries Waterworks Co., cholera no longer posed the threat to public health that it had a few decades previously; however, this was not to say that the supply was reliable, nor that antiquated methods of dispensing water to the public were yet obsolete. Indeed, Newcastle town councillors were, by this period, still discussing the impure state of the water supplied to the borough – water that on some occasions was so discoloured that it 'looked as if it had been taken from a clay hole', and was unfit to drink.

The town's Butchery Pump stood in Ironmarket. It was 'said to be the best [public pump or well] in the town, and the supply never fails' in an 1849 report. However, in August 1877 questions were asked by councillors as to whether the sewage from a nearby drain was polluting the well water that was drawn up by the pump. References were made to the sewage pipes being broken and Dr Edwards, a medical officer, was convinced that sewage had percolated into the well. While the council deliberated, the pump became temporarily out of use but, as months passed, it seems that councillors had reached the conclusion that the pump presented a health hazard to the public. Threats to remove the pump elicited something of a public outcry, with many local residents voicing their

concern in the newspapers, often through forceful (and humorous) letters such as this one:

THE BUTCHERY PUMP AT NEWCASTLE.
To the Editor of the *Staffordshire Times*.
Sir, Will you be kind enough to allow me a little space in your valuable newspaper to state my grievance. I have been a servant to the public of this town for more than a hundred years and have never failed, (only for a short time) to supply the inhabitants with as much pure water as they needed. I have washed their clothes, cleansed their skin, quenched their thirst, washed their floors and steps, and even watered the streets, and now after all that I have done for the public, a few men living close to me have taken it in their hands that I am of no more use and ought to be removed as useless lumber and all because that a short time ago I got a little sick, for want of proper attention on the part of the town authorities. I could not help it, but now I am better and only want a new wooden leg to make me as sound as ever. Mr Editor, do try and save me from disgrace, I don't deserve such treatment. Ask those fat Aldermen and wise councillors to give me another trial and I will try to be in the future as I have been in the past their faithful servant.
THE BUTCHERY PUMP.
Newcastle, Sept. 5th, 1878.

A letter from another anonymous scribe indicates how divided the town was on the issue of condemning the pump. 'A Lover of Cold Water' lamented that decisions had been made by councillors – influenced by shopkeepers who had labelled the pump an obstruction and a nuisance – but that no meeting of ratepayers had been called to discuss the matter. This correspondent cited the pump's good service to the town over many years and suggested that it be replaced by a new one. Ultimately, the town council decided – on the casting vote of the mayor – to remove the pump. Some enraged residents in the habit of regularly using it now complained that it was their only source of water on the occasions when the Waterworks Company's mains froze up, or when the company's water was filthy and not potable. A memorial in favour of retaining the Butchery Pump fell on deaf ears, and in September 1878 the council took action. 'After being draped in black by those probably who will mourn its departure, the pump was removed by the borough surveyor and his assistants, the well so covered in, and nothing now remains to mark the spot so long and so honourably occupied by this old and faithful servant to the town.' Its demise was lamented in the following verse, submitted to the *Staffordshire Times*:

EPITAPH ON THE OLD PUMP AT NEWCASTLE-UNDER-LYME.
Under this stump, lies the Butchery Pump
One fine Autumn morning, without warning
In the month of September, if I rightly remember
In the year seventy-eight I was doomed to my fate.
Some men of position, got up a petition
To get me discharged, and the roadway enlarged

Seven said I must go! and seven said no!
Therefore the Mayor who sat in his chair
At last did decide I should not abide
Before I'd the sack they draped me in black!
They buried me in here without shedding a tear
If I'd kept myself pure and free from the sewer
'Tis certain and clear I should not have been here.

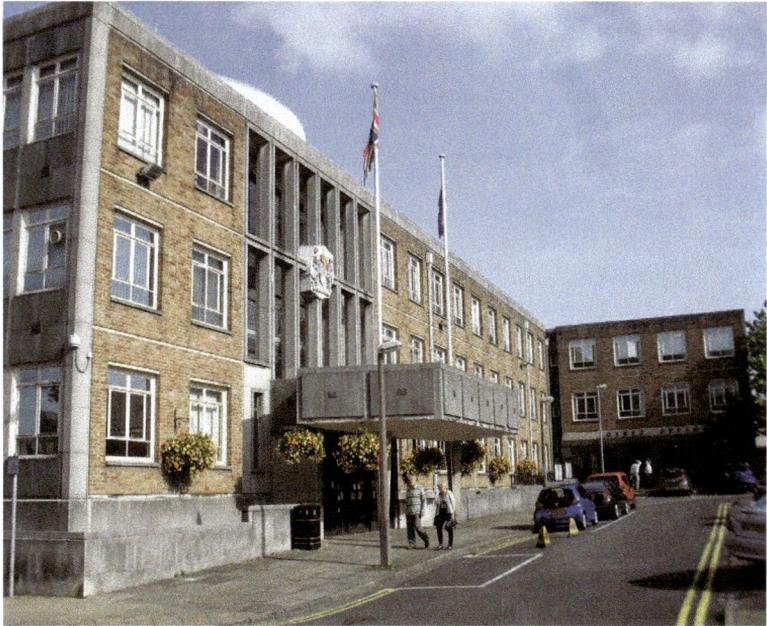

Civic Offices, Merrial Street, Newcastle, 2015. The offices were officially opened in 1967.

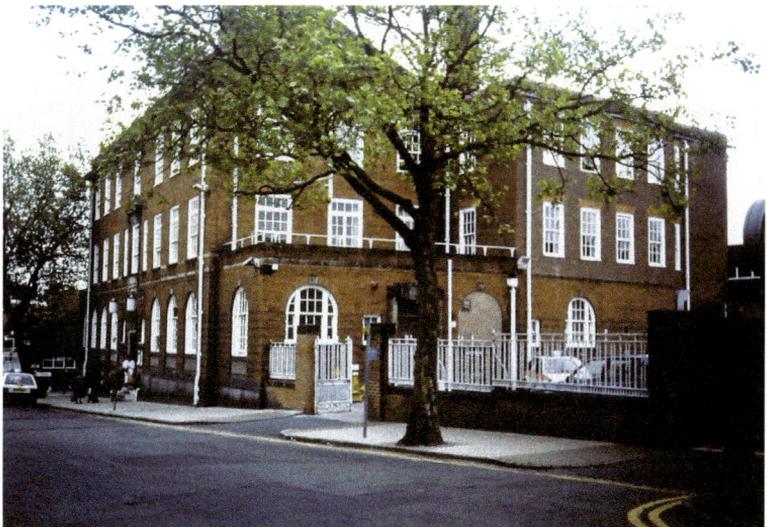

Police station, Merrial Street, 1994. It was opened in 1936.

The subject of policing in Newcastle is a variegated story, and it should come as no surprise that the availability of alcohol continually undermined social control. This is evidenced by the reports of the magistrates' courts, which tell us much about the inefficacy of policing in the area. A pub landlord knew that he was committing an offence if he permitted a police officer to drink or gamble on his premises, yet such transgressions nevertheless occurred. One such example occurred in 1852 when the landlord of the Victoria beerhouse in Silverdale was charged with harbouring three officers in his house and allowing them to gamble with dominoes. They also drank ale that was supposedly given to them rather than paid for. However, this cut no ice with the magistrates, who, wishing to reduce cases such as this, fined the defendant heavily.

DID YOU KNOW?
Newcastle had a borough dog pound, though a press notice of 1870 reveals that the police had given temporary accommodation to a 'two year old blue brindled bull of the shorthorn breed'. The police declared that if not claimed within seven days, it would be sold in order to defray expenses.

On the subject of poor standards of policing, we should also mention that Isaac Cottrill, lionised for his role in protecting Newcastle from the threat of Chartist rioting in 1842, later fell from grace. In 1849, the town's Watch Committee found him guilty on two occasions of drunkenness and absenting himself without leave from duty. Following his dismissal, it was also found that he had embezzled funds from the Fire Account. Perhaps there was only one logical course of action for him to take. Sure enough, he became the landlord of the British Flag, and we find him described by the *Staffordshire Advertiser* in 1850 as 'Newcastle's delinquent ex-Chief Officer of Police'.

Other public services developed haphazardly, too. Firefighting methods remained primitive until well into the nineteenth century, as illustrated by a near disastrous fire that was extinguished by what can only be described as a community effort in 1865.

This took place at the Mr Evans' Colour Works in Bath Street. It was extinguished by military officers and their men, the police superintendent and his staff and by townspeople. The fire had been fierce enough to have posed a threat to the neighbouring business of F. J. Ridgway's brewery, with the consequence that Mr Ridgway saw fit to include a notice in the *Staffordshire Times* thanking all parties who had put out the fire. He also highlighted the inadequacy of firefighting equipment by adding that 'I would respectfully call the attention of the public to the lamentable fact that NO WATER could be obtained from the Water Works Company mains for one hour and a half after the discovery of the fire! Had it not been for the pumps on my own premises, the whole street might have been reduced to ashes.'

Mr Ridgway's brewery may well have been burnt to a cinder two years later, with the local press reporting a now familiar story: 'Outbreak of Fire, And No Water, As Usual'.

The fire had broken out in the stables at the brewery, with the police and Newcastle's primitive firefighting force rushing to the blaze. However, two years after the brewery's last scare, new firefighting equipment had been acquired in the shape of L'Extincteur, a portable fire engine, evidently with a self-contained water supply. The stable roof and a large quantity of straw were ablaze, but the little engine soon subdued the worst of the fire. The borough fire engine had also arrived on the scene, but it proved impossible to coax any water out of the plug at the top of Bath Street. The *Staffordshire Times* described the work of L'Extincteur as 'astonishing'. Thanks to the new equipment, no damage had been incurred beyond the stable. And if the report of this incident reads a little like an advertisement for the new paraphernalia, no effort was spared on the same page to trumpet its effectiveness:

FIRE' FIRE! FIRE!
The only Speedy and Effectual means of EXTINGUISHING FIRE, is by the PORTABLE FIRE ENGINE, L'EXTINCTEUR. Agents for NEWCASTLE and POTTERIES, JOSEPH BAILDON & Co., NEWCASTLE.
See report of Fire at Mr Ridgway's Brewery ... in this paper.

However, with the advent of a more reliable water supply and an improvement in brigade efficiency, firefighting became a somewhat competitive business. In 1928 the Stoke-on-Trent fire brigade attended a fire in Basford Park Road, Basford, not thinking to pass the call on to the Wolstanton fire brigade, whose station was nearer. It was reported at a Wolstanton Council meeting that the Stoke brigade had not only acted in a high-handed manner but, in sending three engines to Basford, where they fought the fire for an hour, they had left the city area 'entirely unprotected'. They had not contacted the Wolstanton brigade until after the fire had been extinguished. The council decided to bring this to the attention of the city authorities.

DID YOU KNOW?

The severity of punishments for petty crimes is illustrated in a newspaper report from 1887, when four boys aged between twelve and fifteen pleaded guilty to stealing some biscuits from a shop in Higherland, Newcastle. They were ordered to receive twelve strokes each with the birch rod.

Relatively few people know that Wolstanton could boast of its own brigade, and this prompts us to mention another aspect of 'secret Newcastle-under-Lyme'. If you have no reason to visit Ellison Primary School, then it is unlikely that you will be aware that an interesting plaque linked to local firefighting is displayed in the assembly hall. For the reason why, we must first go back to 1908, when Wolstanton United Fire Brigade's own fire station was opened in Lily Street. Incorporated in the scheme was a town yard and rate

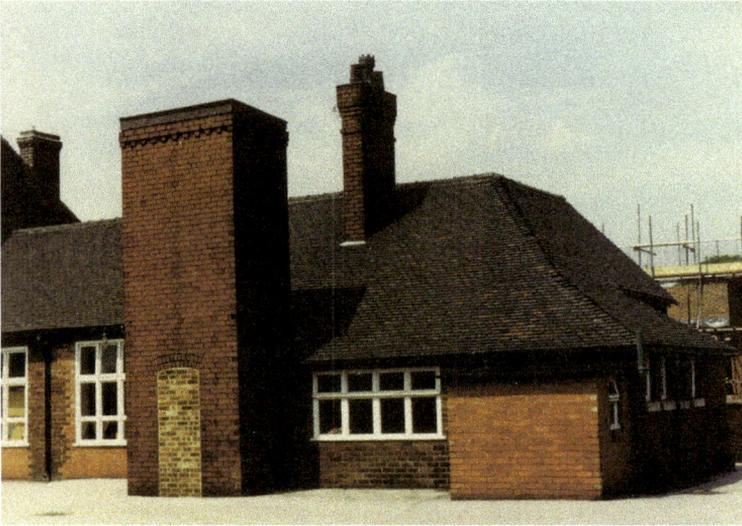

Former fire
station building
behind Ellison
Street School,
Wolstanton, 1980s.

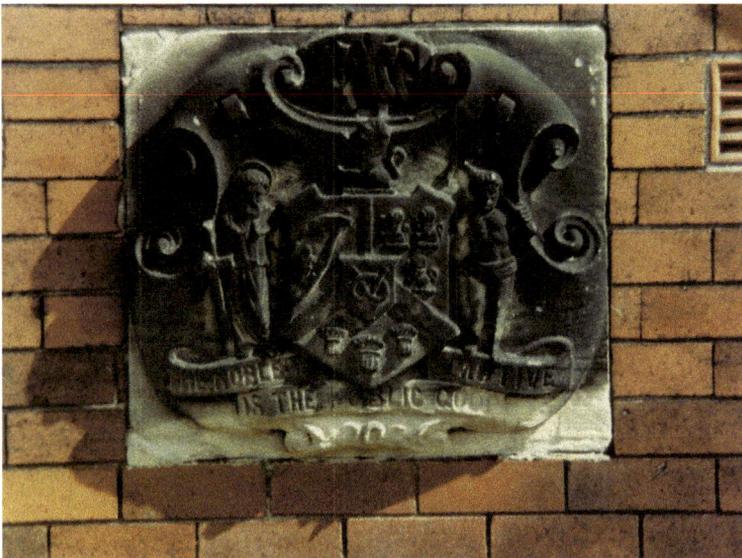

Plaque on former
fire station
at Lily Street,
Wolstanton,
1980s.

collector's office. A drawing of these brand new premises appeared in the *Staffordshire Sentinel* at the time. Particularly conspicuous on this illustration was a 45-foot-high brick tower that was described at the time as a 'drying tower for lengths of hose'. A remnant of the tower may be seen on the (later) accompanying photograph. The *Sentinel* gave a detailed description of the technical specifications of the station and its new horse-drawn steam fire engine, which could throw a jet of water to a height of 150 feet. The brigade was keen to show off this new amenity: at the opening ceremony of the new station, two horses were harnessed to the engine, duly pulling it to Wolstanton Marsh, where a

demonstration was enjoyed by a large crowd. The wider history of the brigade is another story for another time, but what became of the plaque?

The old building ultimately saw change of use, and was suggested for conversion into a child welfare clinic in the late 1940s. However, in 1951, the building was sold by Newcastle Corporation to Staffordshire County Council for £1,300 and the buildings were later to be used for additional accommodation of the Ellison Street Primary School pupils, whose school was to the rear of the former fire station. The plaque was subsequently remounted within the school building and remains there to this day as a relic of the days when Wolstanton had its own fire brigade.

Newcastle-under-Lyme and Stoke-on-Trent today remain two very separate local authorities, but down the years various proposed mergers have been discussed, as well as their potential benefits to local government and public services.

John Wilcox Edge, a towering civic figure, was described as the 'Grand Old Man of Burslem and the Potteries' at the time of his death in 1923. Some readers have probably seen old picture postcards, captioned, 'Wolstanton, Burslem'. Wolstanton was never actually a part of Burslem, but might well have been had history taken a different turn. As mayor of Burslem between 1889 and 1891, Wilcox Edge was one of several figures who promoted a movement for the annexation of Wolstanton, which was then a rural district council. However, we read that the Wolstanton 'Old Brigade' resented the suggestion and it fell through. In 1930, Parliament discussed the Stoke-on-Trent Annexation Bill, which proposed that Stoke-on-Trent Corporation should annex both the borough of Newcastle-under-Lyme and the UDC of Wolstanton. The Bill was passed by the House of Commons on the basis that central government for North Staffordshire was in the best interests of the whole district – a view held by some commentators today. However, it was summarily thrown out in the House of Lords. The decision gave rise to much celebration in Newcastle and Wolstanton, where 90 per cent of inhabitants had voted against being taken over by Stoke. Newcastle marked the occasion by conferring the freedom of the borough on the Earl of Dartmouth and Colonel Josiah Wedgwood for their services in opposing the Bill. Wolstanton, by the way, was ultimately absorbed by the borough of Newcastle-under-Lyme in 1932.

DID YOU KNOW?

In 1885 the Guildhall clock was being cleaned by workmen when one of the copper wire ropes supporting it snapped 'and with an alarming crash the huge pendant fell through two floors and embedded itself about six inches into the stone pavement in front of the Town Hall door'. The 5-hundredweight mechanism fell 48 feet, and it was said that a man standing beneath the portico, upon hearing the crashing overhead, quickly stepped well away. That no fatality took place was fortunate as, on court days, people often congregated in the precise place where the weight fell down.

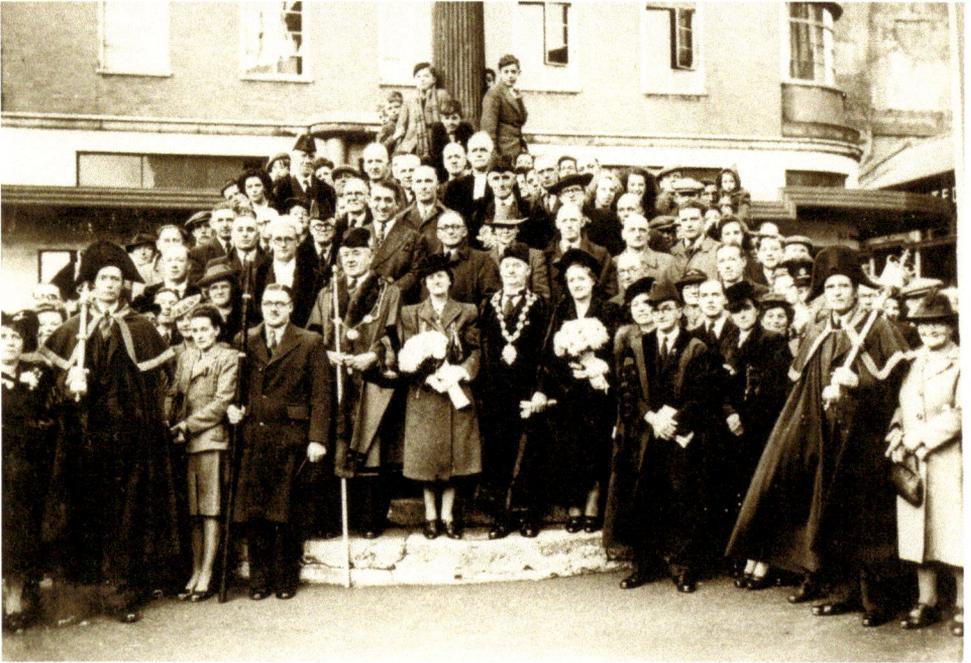

Mayor Knowles and deputies with the town clerk, high constable, mayor's sergeant and members of the council at the Market Cross in Newcastle, 1947.

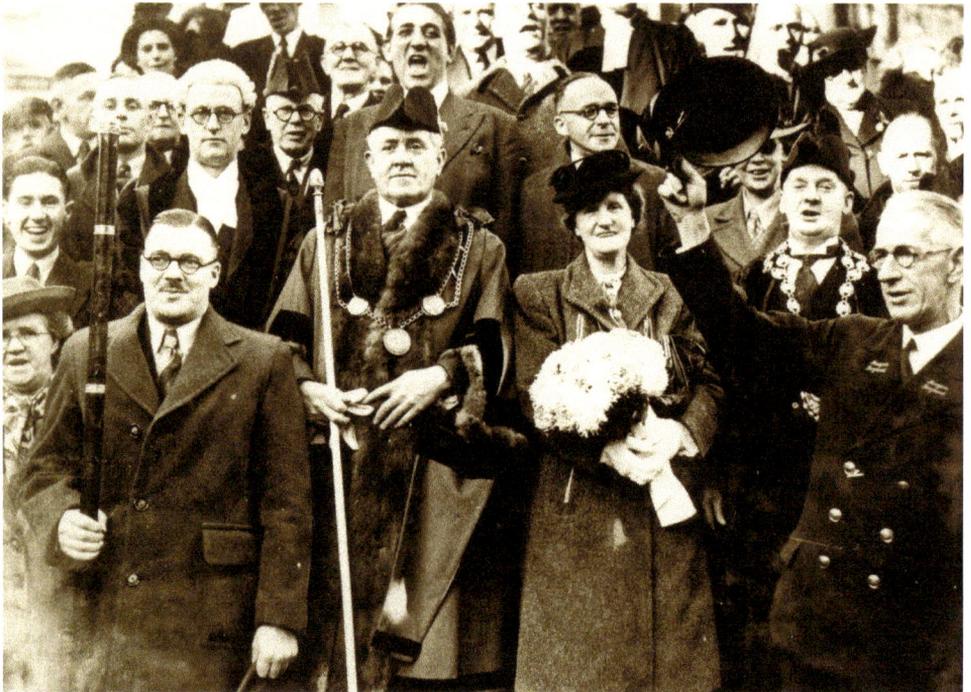

Mayor Knowles and civic dignitaries in Newcastle, 1947.

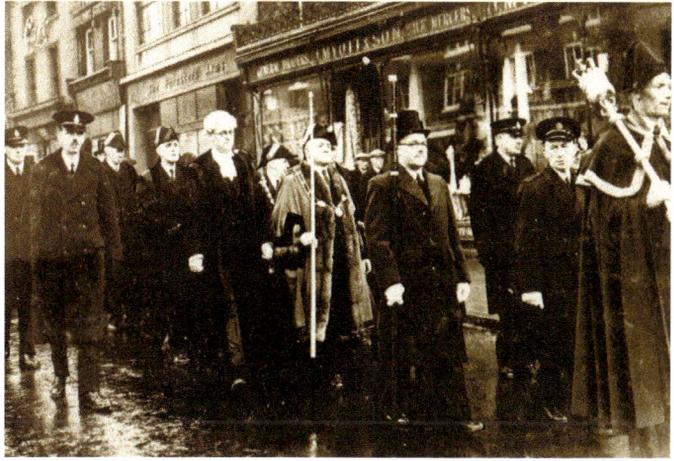

Mayor Knowles and
civic party on the way to
St Giles' Church in 1947.

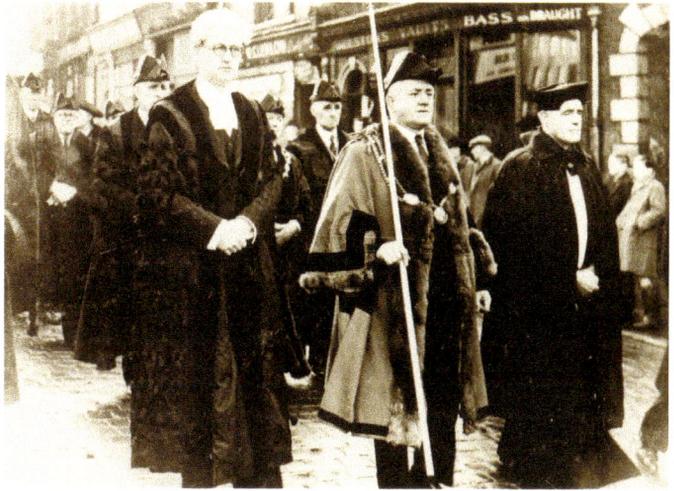

Mayor Knowles and
civic party on the way to
St Giles' Church in 1947.
Note that Beeston's Vaults
(the Wine Vaults) is in
the background.

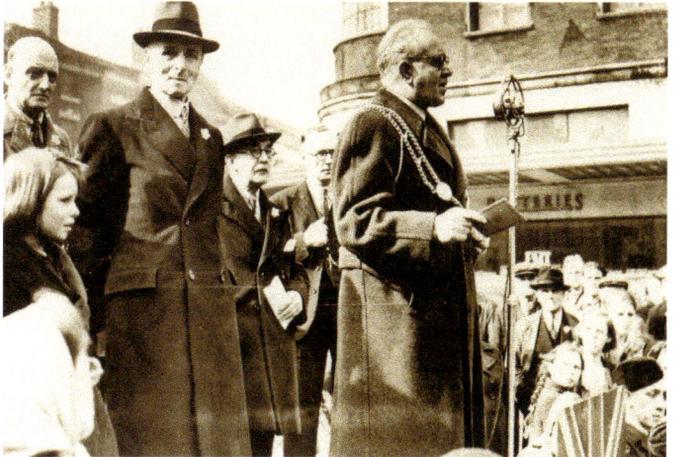

Mayor Knowles opening
the Silver Lining Savings
Fund, *c.* 1948. The
Lancaster Building is
in the background.

6. Shops

For many people, shopping in Newcastle means a look around the Stones – the open air-market that occupies the High Street in front of the Guildhall and which offers a quirkier, more vibrant shopping experience than a tour of the big names in the town. In recent years some marketers, already suffering from competition from cheap shops nearby, have suggested that the borough council could do more to support them. The stalls versus shops debate is nothing new, as will be gathered from robust discussions that took place in 1928 when a deputation from the Markets and Fairs Committee locked horns with the Newcastle Chamber of Trade. What followed was an intriguing and feisty exchange, occasionally embracing what we would now term racism, which emphasises why shopping on the Stones has always offered something different.

CLEMSON'S, RED LION SQUARE, NEWCASTLE-UNDER-LYME. |W. PARTON, Photographer.

Clemson's popular cash drapers in Red Lion Square, c. 1905.

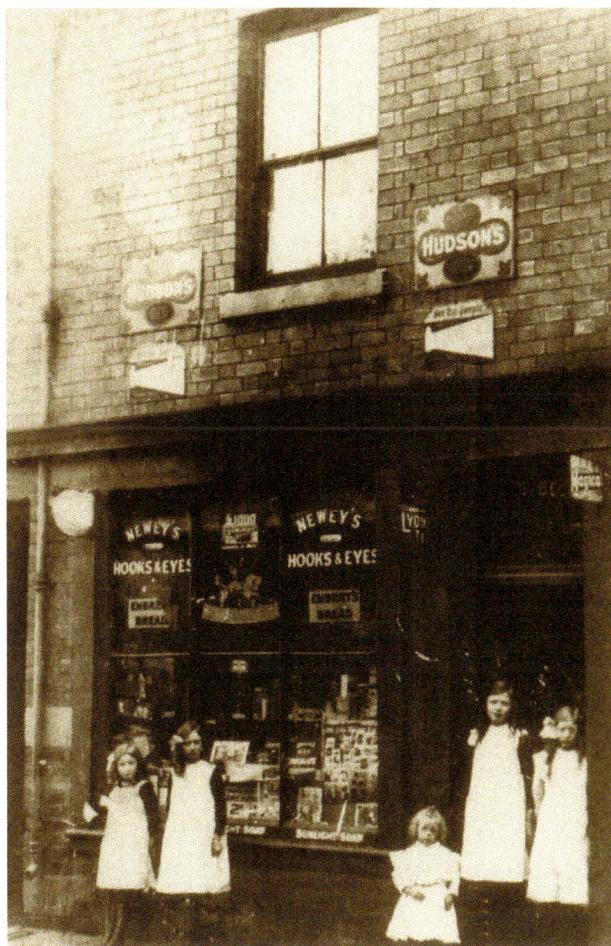

Newey's shop in Lower Green, Newcastle, in the early twentieth century.

Alderman Sydney Myott referred to the regulation that stated any resident of Newcastle-under-Lyme could have a stall, though he had heard recently that six market gardeners had been turned out of their old stalls, some of whom had kept the stalls for decades. So if they were no longer making a pretty penny on the Stones, who was? Myott had visited the market on a recent Monday night and counted no fewer than forty-nine drapers' stalls – more than all the drapers in the town put together. Most of them, he asserted, appeared to be 'Sheenies', Jews and people who came from 'they knew not where' – hence, the *Staffordshire Advertiser*'s description of the Stones as a 'Jews' Paradise'. They, added Myott, paid no rates and were also taking trade away from the permanent shops. The *Advertiser* journalist who penned these observations reported that, following the meeting, Myott had complained to him that the cheap drapers on the Stones were doing a roaring trade and one of the stalls had even been set up in front of a permanent draper's shop. Sidney W. Carryer supported him. The outsiders referred to, he said, came from Manchester, where Newcastle-under-Lyme was known as 'Mug's Town' because of the way it allowed its streets to be thrown open to these people. Mr Weston Poole added

that when the council had appointed a market inspector these problems would arise, and that such a lot of 'cheap-jack' people, selling goods of he knew not what origin, should come to the town shouting disparaging remarks about the shopkeepers. Such were the joys of free trade in Newcastle in 1928, but there have always been tensions between the traders on the Stones and their fixed competitors. The High Street Market Hall of the 1850s (demolished in the early 1960s) sold grocery, tobacco and various goods and in looking directly over the Stones would have presented a direct challenge.

DID YOU KNOW?
A well-known shop in Newcastle was that of G. T. Baggaley, the High Street book binder. He had acquired the business in 1890. He had a fine reputation, having bound books for the royal family and been a librarian for the Duke of Sutherland. Bagguley's were the binders of the novelist Arnold Bennett's books from 1911 to 1931. Mr Bagguley was a Newcastle burgess and very involved with St Giles' Church, where he was a deputy organist and choirmaster. He died in 1950, aged ninety.

Market halls also provided competition for High Street shops, as was noted when Silverdale's new market hall opened in 1870. Initially, it was intended to open it for just two days weekly, but there was an acceptance that other traders might take a dim view of the new facility. In a speech made at the official opening, Revd George Armstrong remarked that he 'did not believe that the establishment of the market hall would be detrimental to the interests of the shopkeepers'. Armstrong and others saw its opening as evidence of Silverdale's aspirations at this time – the village was now connected by railway to Newcastle, and it was envisaged that farmers would bring the produce of their gardens and farms to the market hall to sell. Very few people in Silverdale today will remember the building, which was finally demolished in the 1960s, but its rise and fall presents an interesting story of one man's enterprise. William Steele of Madeley was convinced that Silverdale had required such a facility for some time. He owned a house next door that he wished to be licensed as a public house. In order to induce the licensing magistrates to grant him the licence for the pub (the Royal Oak) he offered to build a market hall alongside it.

The market hall quickly established itself as a valuable amenity, not only selling groceries but also doubling up as an entertainments venue on occasions. The year 1870 saw the Silverdale Band appearing there, while a promenade concert and Handel's Messiah were performed there later in the year. However, the market hall's demise in the mid-1880s came as a result of its failure to compete with local shops. It was later converted into a public hall – still serving the public admirably, but not in the way it had been intended to. On this occasion, the High Street traders had triumphed.

Those who wish to shop for meat in Newcastle-under-Lyme today have the option of several high quality butchers' shops. However, certain emporia in the nineteenth

century were not always a credit to the trade; one news report in 1875 was so shocking that it rightly generated considerable bad publicity for the tradesman involved, namely W. H. Cook, a butcher in Hassell Street.

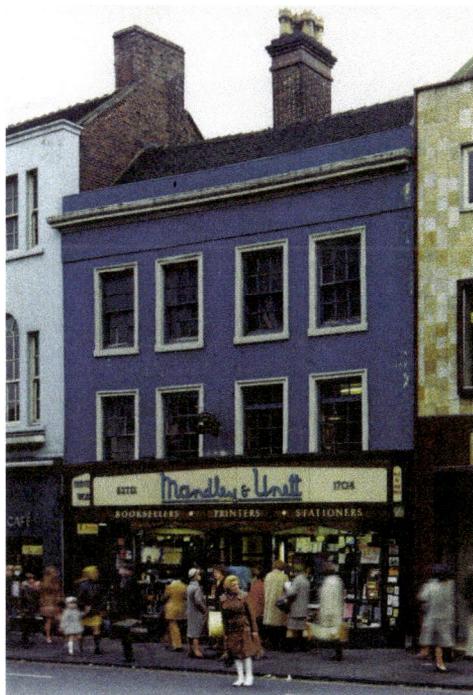

Right: Mandley and Unett's shop in High Street, Newcastle, probably in the 1960s.

Below: Mott's photographers, Hassell Street, Newcastle, early 1970s.

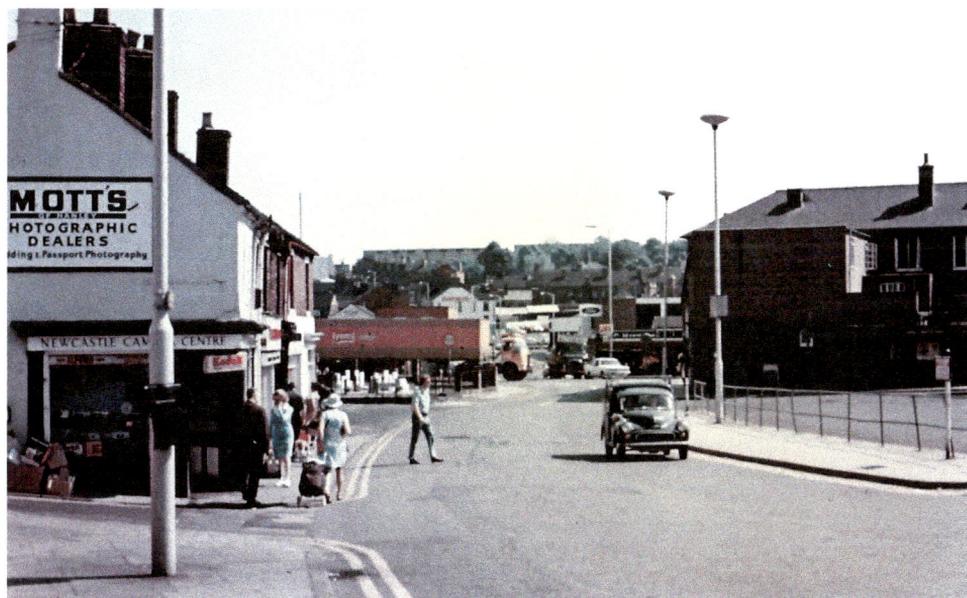

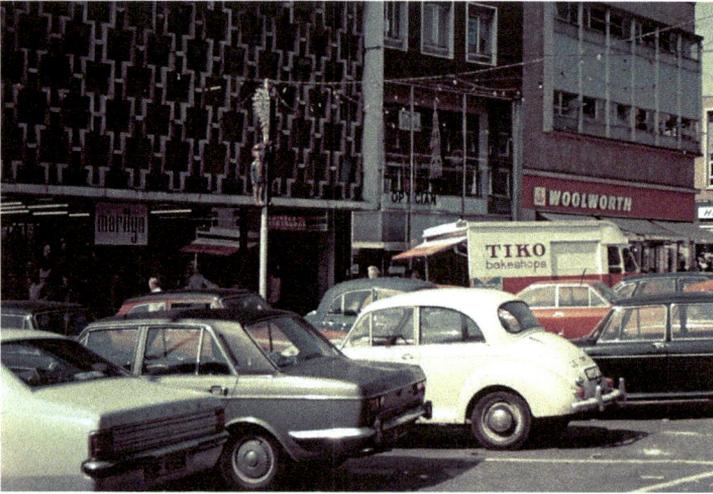

The Market Arcade, Newcastle, in the early 1970s. It opened in 1963.

Newcastle Borough Police Courts heard of the deplorable cruelty of James Heath, who was a journeyman butcher in the employ of Cook. He was accused of taking off part of a sheep's skin before it was dead. The case for the prosecution stated that: 'The knife had been applied to the sheep but ineffectually, for it lived and was writhing and twisting about for some time while it was being skinned. It was literally flayed alive, and after its leg and shoulder had been skinned was seen to raise its head ... a piece of abominable cruelty.'

Police Constable Pugh had been passing Cook's slaughter house when he had heard the sound of stifled groans from some animal, and decided to investigate. The press report gives full details of the heinous act being committed and the torture of the animal. I shall spare the reader the full details of the case, which saw defendant being fined 40s plus costs. Public opprobrium followed swiftly. One correspondent to the *Staffordshire Times*, Isabel Glyn of London, felt that the law had not adequately dealt with the atrocity and that the inhabitants of Newcastle-under-Lyme should procure whips and lash James Heath all through the town. The case even drew censure from the *Pall Mall Gazette*, which reported that it would be difficult to imagine a more disgusting instance of cruelty to animals than that which had come before the Newcastle magistrates. It, too, felt that the incredible brutality of Heath had received but mild punishment.

DID YOU KNOW?

In 1882, Elizabeth Rhead of Tunstall was found to have stolen sundry items of drapery from Mr Briggs' shop in Newcastle. However, they heard that she had recently suffered confinement, the result of which had been 'unusual exhaustion, taken in the form of puerperal insanity which was generally in the form of kleptomania'. The case against her was dismissed on compassionate grounds.

Basic amenities that we take for granted today came to Newcastle very gradually and were looked upon with a degree of wonder by our forefathers. Take the introduction of electric light in the town and the impact it was to have on retail premises. It was first applied to a house of business in the town on a Saturday night in 1879 at the establishment of R. Stanway, draper and clothier on Newcastle-under-Lyme's High Street. The public flocked to the site to see the front of the shop brilliantly illuminated. It was noted that the Guildhall prevented the light from being fully visible along the street, but that it shone far down the street on both sides. This effulgent display came courtesy of Messrs Welch and Scott, electrical engineers from Manchester. Their machines produced a light equal to 6,000 sperm candles, and by the 'switch-on' at Stanway's people were reported to have remarked that the illumination of the street lamps looked foolish in comparison. The vast crowds marvelled over the light-producing apparatus, which included a steam engine necessary for its production placed behind the Guildhall. A full account of the technical specifications and workings of this contraption was given in the local press. It was also stated that the real commercial value of the light could be observed in Mr Stanway's shop, as an open electric light rendered the goods in his interior as distinguishable as they would be during broad daylight. Ladies and gentlemen from the neighbourhood thronged his premises all evening. The whole exercise was repeated two nights later, again attracting

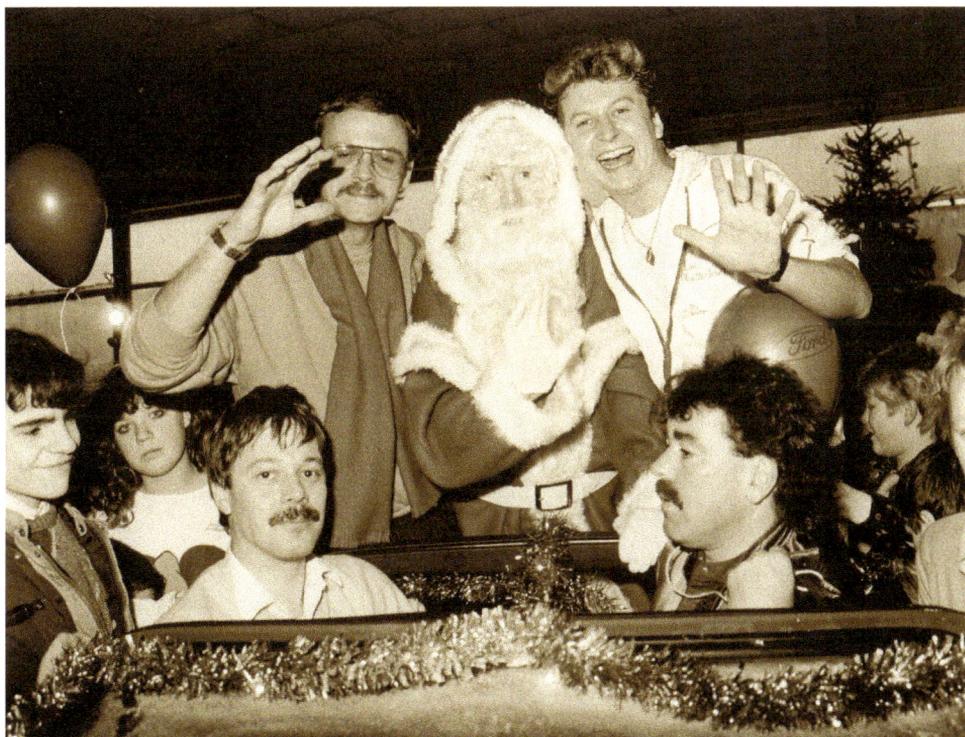

Castle House operated as a successful Ironmarket department store between 1966 and 1991. Mervyn Edwards is seen here in 1986, playing the store Santa Claus in the company of Signal Radio presenters.

Above: Knowles'
hardware shop
in Merrial Street,
Newcastle, 1993.

Left: Fine Fare,
Newcastle, 1994.

crowds, and Mr Scott used a new lamp 'to show the concentration of light'. This was achieved through a lamp on a moveable apparatus. 'A light like a brilliant ray of sunshine, was shot about up and down the street, on the Town Hall clock, on passing carriages and moving objects.' Newcastle had glimpsed the future.

Shops in Newcastle continued to prosper during the First World War, and some of the items sold were spoken much of during those troubled times. For instance, in 1916, Jones, Moss & Co., the house furnishers, advertised their anti-Zeppelin blinds; and Henry White's men's outfitting shop promoted its 'khaki uniforms for officers of all ranks', and its service jackets, ground sheets, sleeping bags, etc., offering 'everything necessary for the complete kit'. However, it was White's Christmas advertisement in 1916 that really caught the eye. In addition to selling its usual ties, gloves, handkerchiefs and other men's wear, it offered:

THE IDEAL PRESENT FOR MEN AT THE FRONT
THE CHEMICO BODY SHIELD.
Proof against Shrapnel at a velocity of 750 feet per second.

The first prosecution in Newcastle under the First World War lighting restrictions came before the bench in April 1916 – Henry White's High Street shop being the transgressor. White was summoned for having his windows lit up by several electric lights, which illuminated the roadway outside to a distance of 40 yards. He explained that he had told his assistants to turn out the lights but, being very busy, they had forgotten to do so. White persuaded the bench to dismiss the case in return for a contribution to the poor box, thus avoiding public relations embarrassment.

Another retail name familiar to many across the borough of Newcastle was Swettenham's Co-operative Institutions, but what do we know about the man who started it all? At the time of his death in 1951, Ernest Swettenham could look back with satisfaction on a life in good, honest retailing. By this time, there were twenty-nine branch stores and nearly 500 employees. He was born in Arclid, Cheshire, but came to Chesterton as a boy. He was apprenticed to a grocer in Silverdale, but after working in different parts of the country, opened his first shop in Wolstanton High Street in 1890. His father was a miner and a Nonconformist and Ernest himself became a Methodist, serving High Street Methodist Church in Chesterton and later Ebenezer Methodist Chapel in Newcastle, where his funeral took place.

One major name in the town was Paulden's, a fine department store in High Street that originally opened in Newcastle in 1946. In today's retail world, the relationship between management and staff differs drastically from the days when the welfare of staff was seen as important. Paulden's even had a staff choir. In 1960 this ensemble, conducted by Mr A. L. Rowley, presented carol concerts at the almshouses in Newcastle and the Hillcrest Hostel in Wolstanton.

Two large stores in Newcastle were virtually rebuilt in the late 1950s, yet we can hardly say they reopened because they never closed throughout the duration of their reconstruction. Paulden's new look was unveiled in 1957 and Woolworth's in 1958.

The most controversial building that ever served as retail premises in Newcastle was undoubtedly the Fine Fare building overlooking the Stones. It was owned by Gateway, who took over the Fine Fare chain. It was intended as a revolutionary concept in High Street shopping and, in many respects, it was the 1980s version of the Market Arcade of 1963 – an attempt to combine high street shopping with superstore shopping in the town centre – and, like the 1963 building, it was big, brash, functional and out of synch with the rest of the town.

Xceptions, Ironmarket, Newcastle, 1994.

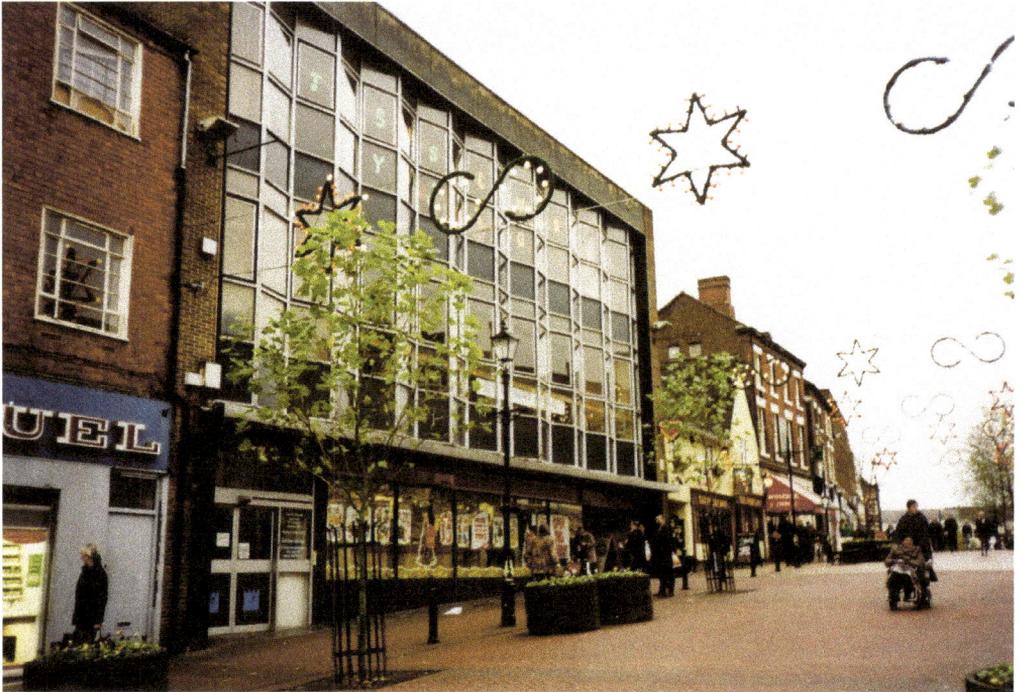

Wilkinson's in Ironmarket, 2000.

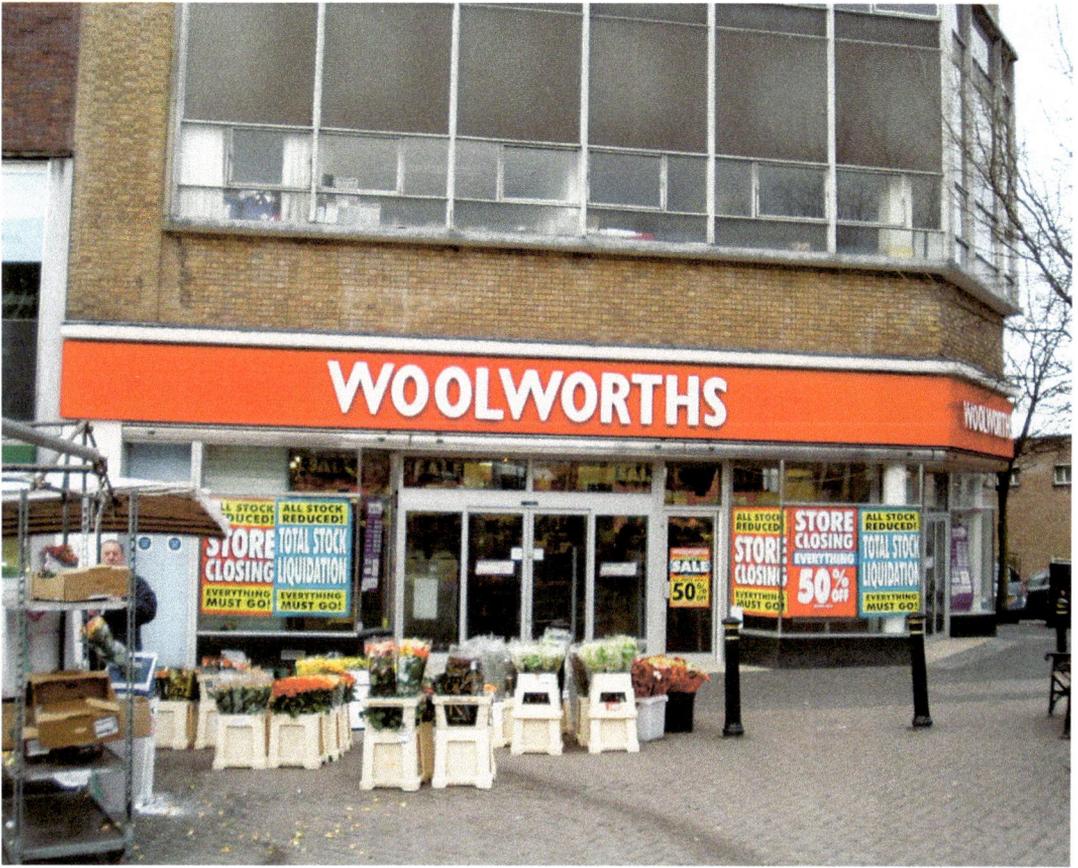

Woolworth's store, High Street, Newcastle, 2008.

DID YOU KNOW?
An *Evening Sentinel* advertisement for the newly opened Cee-and-Cee in 1968 would perhaps annoy today's feminists. It declared, 'Inside, a row of sixteen armchairs greets the customer. Here, hubby can relax as his wife goes round rows of well-stocked shelves, or picks the weekend joint from the finest cuts of meat in the butchery department.'

You may wonder why the borough council allowed it in the first place. It was felt that the town badly needed a supermarket, as well as more car parking space, and the building had a multistorey car park attached. It boasted Fine Fare's garish colours – orange, white and bottle green – and consequently became dubbed the Rubik's cube. It was a building that you couldn't miss, and even became used as a geographical beacon by airline pilots heading for Manchester airport. Llin Golding MP spoke about it in the House

of Commons in 1987, saying it was a 'monstrosity' that was totally out of keeping with the rest of the town and the worst piece of architecture in the town's 800-year history. The store once topped a national newspaper poll as Britain's ugliest building. It is no secret that this building was loathed by most Newcastilians, who were strident in their criticism. However, there was another side to the story that wasn't really revealed until 1990 and, given the furore over the building, it is well worthy of inclusion in this book. Its architect, Ralph Baldwin, gave his view in the local press: he argued that when he and his partners designed the store, there were *no* garish stripes on it. They would have been inappropriate, he reasoned. However, Fine Fare then applied to the borough council for consent to display an advert. The council complied and the architects were then asked to incorporate the logo. Reluctantly, they did this, and consequently were pilloried by the public.

7. Education

Newcastle-under-Lyme could boast of many disparate bodies of learning in the nineteenth century, from charity schools, denominational and Sunday schools and state schools to self-improvement clubs, art schools and literary institutions. Educational provision was even created for the most lowly and impoverished, and in this respect mention of Newcastle's ragged school is well worth discussion.

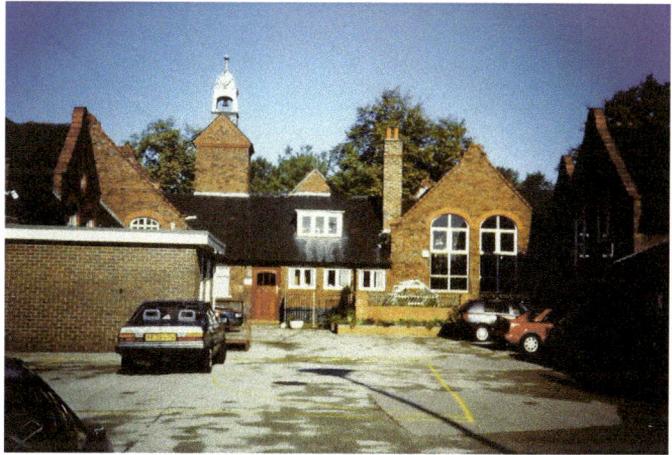

St Giles' and St George's School, Newcastle, 1994.

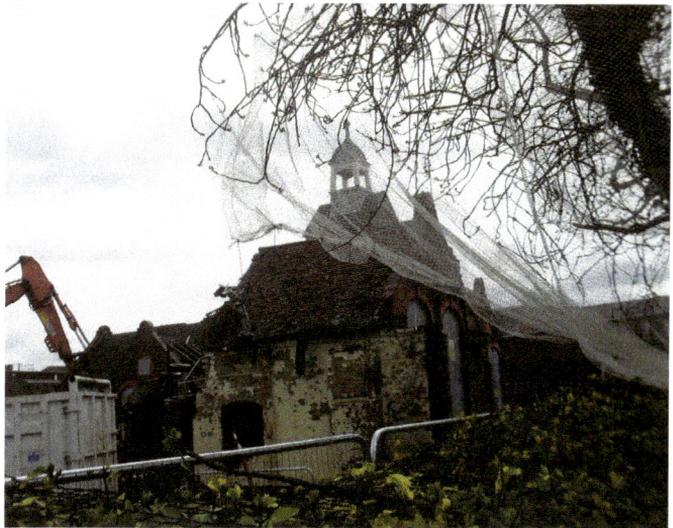

Demolition of St Giles' and St George's School, 2016.

The origins of the ragged schools go back further than 1844, but in that year the Ragged Schools Union was founded, being vigorously championed by Lord Shaftesbury. These schools – funded by philanthropists – provided free education, food, clothing and sometimes lodging for the destitute elements of society. Newcastle's ragged school provides us with a good example of how the schools worked.

It opened in 1862 in Hatherton's Yard, Ironmarket, Newcastle, aiming to provide for children and adults, who through their poverty and other causes were unable to attend other schools in the town. The school began with forty scholars and convened in premises loaned by a Mr Warham. Reports of the school's activities reveal that the children were often provided with good food, especially at Christmastime, when treats to the ragged school were regularly organised. However, it is the annual reports of the Newcastle school that offer priceless material as to how it operated. Finances were inevitably discussed and we glean much interesting information about the progress made. By June 1863 the school's numbers were increasing to the point where a move to more commodious premises was already being suggested. There were Sunday evening services and a twice-weekly night school taken by unpaid teachers. The plan was to open the night school every evening and to have a regular, paid teacher running it. In December 1863, having secured funds from several benevolent individuals wishing to promote a Christian education, the school moved to bigger premises in the Upper Green, which had previously occupied by the Congregationalists. Newspaper reports speak of devotional exercises lessons. By 1870 the Sunday school's average attendance was 270 and the day school 150. The children, it was reported, 'were generally clean' and there was a clothing club that provided these needy children with garments, which had been given by several ladies. The town missionary ran religious meetings on Sunday evenings and a Bible class on Wednesday evenings. A Band of Hope had also been formed by this time to nourish temperance among attendees. The annual report of this year referred to the sick and destitute scholars that the school had relieved, with the donation of Bibles and other books from the rector of Newcastle and other donors. The school was progressing sufficiently to be considering further expansion. With the advent of board schools from 1870, the need for the Newcastle's ragged school became less acute. *Keates' Directory* of 1892–93 informs us that the school – still supported entirely by voluntary contributions – closed on weekdays but was well attended on Sundays. However, its impact on the lives of the poor over the previous thirty years had reflected well on the beneficent nature of some of the more affluent sections of Newcastle society.

DID YOU KNOW?

In 1862, William Bainbridge, a teacher at the Wesleyan day school in Chesterton, found himself up before the magistrates' courts, having brutally assaulted William Dutton, aged seven, with a cane. The boy's back and shoulders were so covered with livid bruises that he appeared to have been punished with a poker rather than a cane. The magistrate Thomas Bailey Rose, who himself had a reputation as a disciplinarian, remarked that the defendant had 'as nearly murdered the child as he had dared'. Bainbridge was sentenced to prison with hard labour for two months.

Many educational bodies aimed to bring enlightenment to the more affluent working men, such as Stoke's Socratic School, which opened in 1830 and was promoted by Revd Benjamin Vale. The Newcastle Literary and Scientific Institution, established in 1836, had similar objectives and advertised many meetings or lectures that were as entertaining as they were educational. Take, for example, the visit of General Tom Thumb in 1846. He was about to depart for America but had been on tour for two months, attracting huge audiences. He was advertised as being fourteen years of age, 25 inches in height and weighing a mere 15 pounds. He offered costumed performance and song, and the Institute advertised that a separate performance would be given to accommodate the working classes – with a discounted admission of sixpence. The *Staffordshire Mercury* recorded that 'Kings and peasants – Queens and washerwomen' had been among the 3 million people estimated to have seen him on his travels. 'No exhibition of modern days has been so attractive, or so profitable, as that of the Lilliputian hero.'

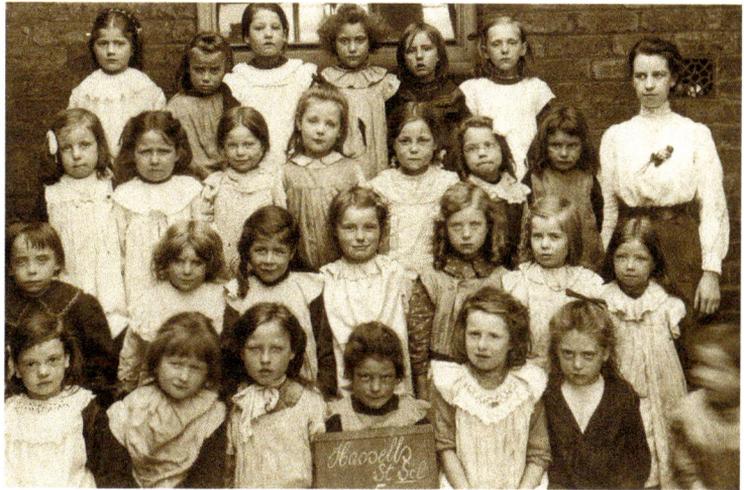

Hassell Street School pupils, date unknown.

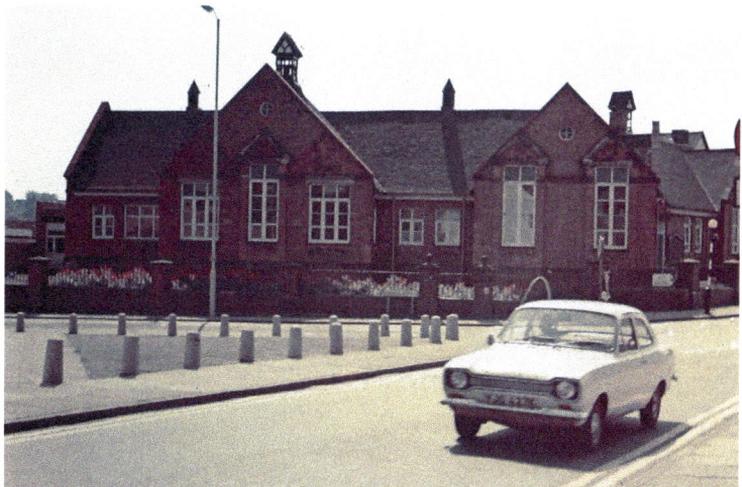

Hassell Street School, Newcastle, in the early 1970s.

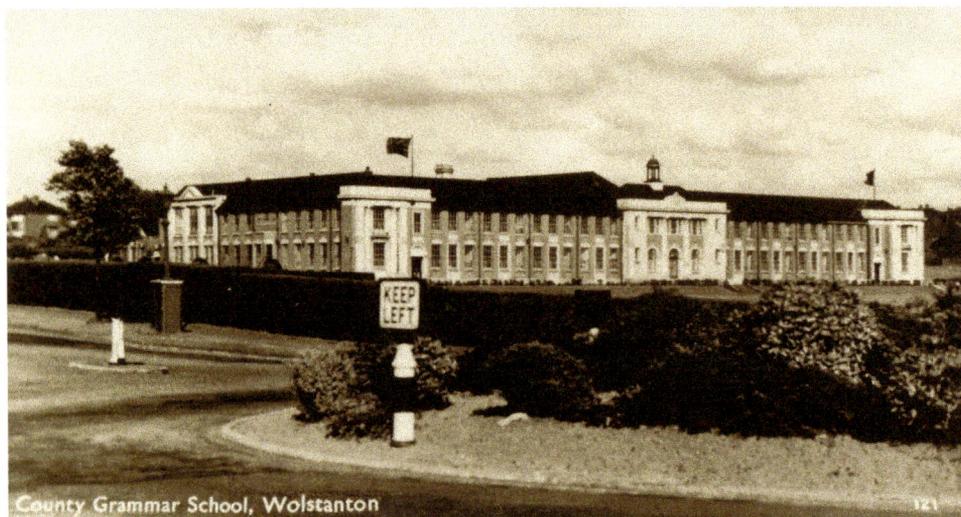

Wolstanton Grammar School, date unknown.

The findings of school inspections yield interesting information about schools in the past, but few had such far-reaching consequences as the inspection of the Orme Boys' School at Higherland in 1923. Its details record 'deplorable' conditions triggered by the fact that the premises had become too small for its 391 boys. Prayers had to be read in a nearby church, while a chapel and three other buildings in the town were being used to for overspill. The rise of the motor car had also created problems – the pupils having to be careful of the traffic when walking between sites. In addition, it was reported that the classrooms in which oral French was being taught were exposed to the noise of passing traffic, hampering the lessons. Contrasting starkly with today, we find that the school laid a heavy emphasis on articulate speech – hence the inspection's criticisms of standards of English and the unsatisfactory 'enunciation' of the boys. At a subsequent meeting of school governors and inspectors, Chief Inspector Fletcher pressed home the point: 'Speech ought to be more distinct.' However, it was the inconvenience of the site that eventually led to a change of location and name. The Wolstanton County Grammar School opened in 1928.

DID YOU KNOW?

The dinners of many of today's scholars are often sourced from a takeaway or sandwich shop near to their seat of learning. Arrangements were a little more rigid at the Orme Boys' School in Newcastle, according to its prospectus of 1923, which demanded: 'Lunch brought to school by the boys themselves must be packed in a serviette and enclosed in a luncheon tin. It is EXCEEDINGLY UNDESIRABLE for parents to give boys money with which to buy their own lunch.'

School log books offer invaluable information as to the organisation of education in times past, providing an insight into school curricula, disciplinary standards, educational excursions, illnesses and reasons for absence. The log books for what is now Ellison Primary Academy in Ellison Street, Wolstanton, are to be found in Stafford Record Office and are well worthy of scrutiny. If the past really is a 'foreign country', there would appear to be plenty of evidence here, with references to cramped accommodation, young teachers being called up to fight for their country, and absence through diseases that we rarely speak of today. Measles, ringworm, scabies and various other skin ailments are regularly mentioned, but it is the scale of some of these health problems that is illuminating. Towards the end of the First World War, there are several log entries concerning the prevalence of influenza – this being a reminder of the deadly Spanish flu pandemic of 1918–20, which infected 500 million people across the globe.

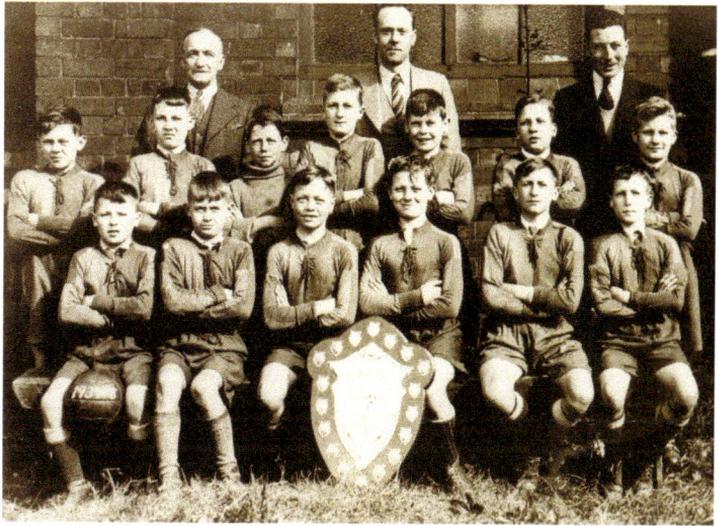

Ellison Street Primary School, Wolstanton, junior football team, 1937–38.

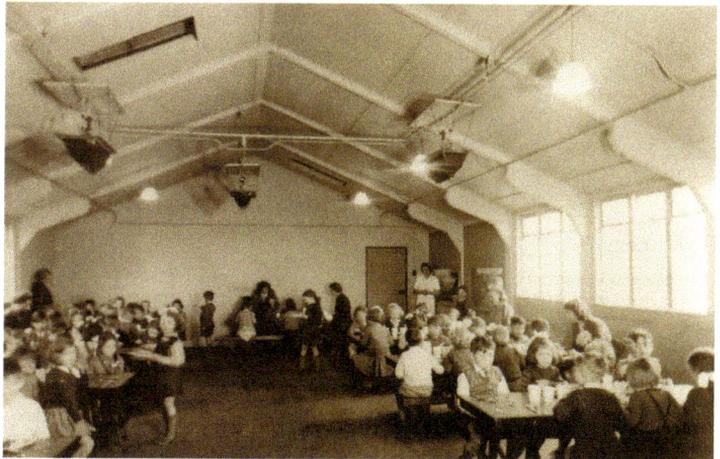

Ellison Street Infants' School, c. 1950.

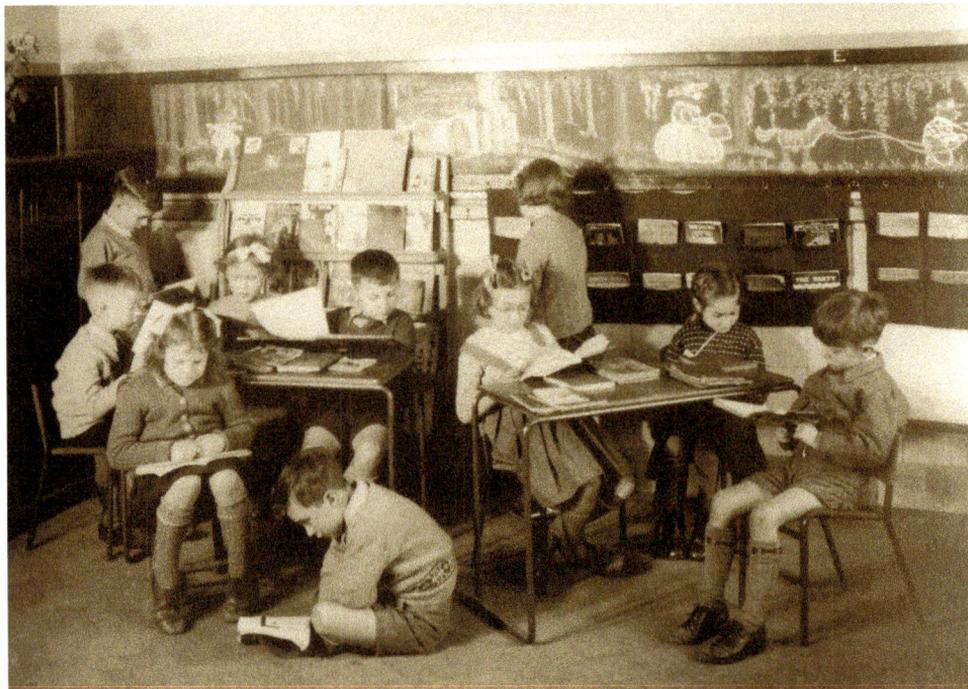

Ellison Street Infants' School, *c.* 1950, Class 6.

Other reasons for absence were more commonplace and remind us of the extreme weather conditions of the past. On 2 April 1917, so many children were absent through a severe blizzard that those who did brave the elements were sent home for the day. School attendance in mid-January 1931 was recorded as being the lowest for around a year on account of the cold and fog, though influenza had also taken its toll.

Another entry, for 15 April 1918 recorded that attendance was fair but that there was much sickness among the children and a case of scarlet fever at Catherine Street, May Bank. With influenza reported to be prevalent at the school by October 1918, the school secretary ordered the headmaster to close the school. Influenza was rife. The school did not reopen until 18 November, following a hiatus of three weeks and two days. One male pupil died during the enforced break, though the cause of death is not stated.

The school nurses were very busy at times, dealing with maladies that speak of primitive or insanitary living conditions. Several pupils are referred to as having a 'verminous head' or a 'hollow back'. In the winter of 1920 attendance fell away a little through the pupils' involvement with coal-picking. Occasionally we find other indications of poverty in the log books; in March 1922 the school admitted a female pupil who lived in a van in Minton Street, though the note that she was only expected to be at the school for a few weeks might suggest that she was from a travelling family.

Many log entries reflect the spirit of the times in which they were written. The log entries tell us that the school was closed 'for an extra two weeks' following the outbreak of the Second World War, and that air-raid shelters were swiftly provided for pupils and

teachers. In October 1940 all the windows in the school were treated to resist blast effect, then in September 1941 the windows were treated with anti-splinter netting. The last school air-raid shelter was demolished in 1971.

DID YOU KNOW?
Wolstanton County Grammar School was an impressive seat of learning. It opened in 1928, but its structure was very quickly threatened by mining subsidence – Wolstanton Colliery was less than half a mile away. Movement of the foundations and cracks in the brickwork led to the whole school having to be rodded from the summer of 1938.

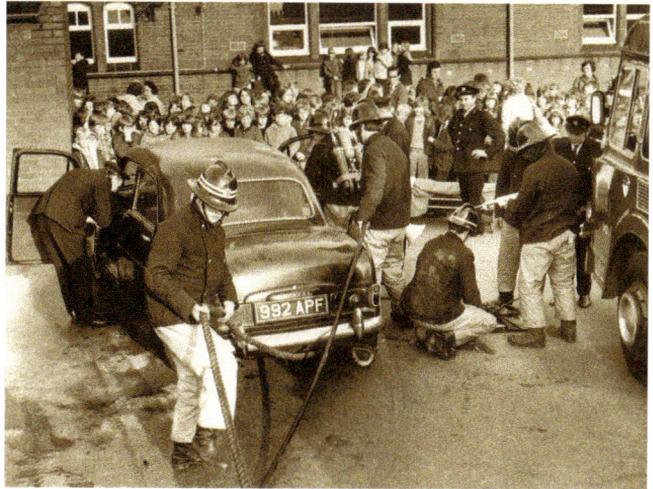

Operation DATEC at Ellison Street School, 1960s.

Ellison Street School netball team, 1976–77.

Ellison Street School netball team, 1986–87.

8. Religious Worship

Religious buildings come in all shapes and sizes, but what would it have been like to worship in a 'flat-pack' church? We refer to a temporary iron construction, erected for the benefit of the congregation of St Giles' Church in Newcastle in the 1870s. The church was rebuilt between 1873 and 1876, and it was necessary to provide an alternative place of worship for the church's flock. Thus, a temporary church was erected in Ironmarket.

The church could seat around 600 people and originally saw service at Kingston-on-Thames in 1870. It was purchased from the vicar of that place and taken down over a period of thirteen and a half days and packed into bundles ready for reassembling at Newcastle.

It was re-erected in Ironmarket over the course of just over three weeks, and was seen to be a plain building with Gothic details and a square pitched roof fitted with a bell turret. Internally, it measured 84 feet long by 40 feet wide and included a chancel, organ chamber and vestry. The walls were constructed of a skeleton framework of wood, cased with corrugated and galvanised iron, secured by screws and lined throughout with stained boarding. It was a well-ventilated building, heated by stoves. An organ was fitted and, upon its opening, it was reported that the large congregation seemed charmed with the accommodation and with the rector's preaching on that occasion. Work could now continue with full speed of George Gilbert Scott's new St Giles' – but there is a postscript to our story of the iron church.

It had been reported of the temporary church that it was so assembled to facilitate it's being taken to pieces and removed to another site without material injury. This is exactly what happened. In 1877 it was announced that it had been purchased by Revd Sir L. T. Stamer, rector of Stoke, and was to be re-erected at Boothen to serve that area's people pending the building of a new church. Once re-erected at Boothen, the 'recycled' iron church lasted only a few weeks before it was blown down in a severe storm.

DID YOU KNOW?

A little piece of Newcastle could once be found in Hanley Park: the iron gravestone of John Smith (dated 1614), son of Alderman John Smith. This had been sold as scrap by St Giles' Church in Newcastle to Kirk's foundry at Etruria in 1874. It was ultimately given as a gift to the park by Alderman Shirley and was placed by the 'dingle', where it remained until 1911, after which it returned to its rightful home in St Giles' Churchyard.

The Ironmarket building was not the only iron church known to Newcastilians, as the Baptists, having acquired a site in London Road in 1871, built their own iron church with schoolrooms underneath. It was designed and erected by Messrs Francis Morton and Co. of Liverpool, who were described as 'well-known iron church builders'. This was replaced by a permanent brick church, erected on an adjacent site in 1914.

St Giles' Church in Newcastle-under-Lyme can speak of a variegated history throughout its several designs. As one of the town's moral guardians and a political force to be reckoned with, it was always keen to exert its influence through events, choral efforts and age-old customs. One such custom was the perambulation, otherwise known as the beating of the bounds (or boundaries) of a parish. Historically, this involved the church vestry members investigating the boundaries of their parish to ensure boundary stones and other markers hadn't been removed. Long after this was a necessity, it remained a ritualistic custom. A trawl through the local press reveals that in 1887 the St Giles' perambulation was revived for the first time since 1865. Reading the report of this event, we glean some idea of how the perambulation was carried out as well as the difficulties and the fun involved.

The 1887 affair had been advocated by Mayor Mellard as a way of marking Queen Victoria's Jubilee year, but also found favour with those concerned with preserving Newcastle traditions. The area to be covered had also grown since 1877: it was estimated that around 6.25 miles would need to be walked. The route occasionally posed problems, as when the walking party proceeded down Occupation Road towards the London Road Tavern, which, according to the *Sentinel* was on the boundary line and 'ought, strictly speaking, either to have been crossed, or passed through'. Instead, the walking party merely included the whole property as part of the boundary. Another challenge was posed

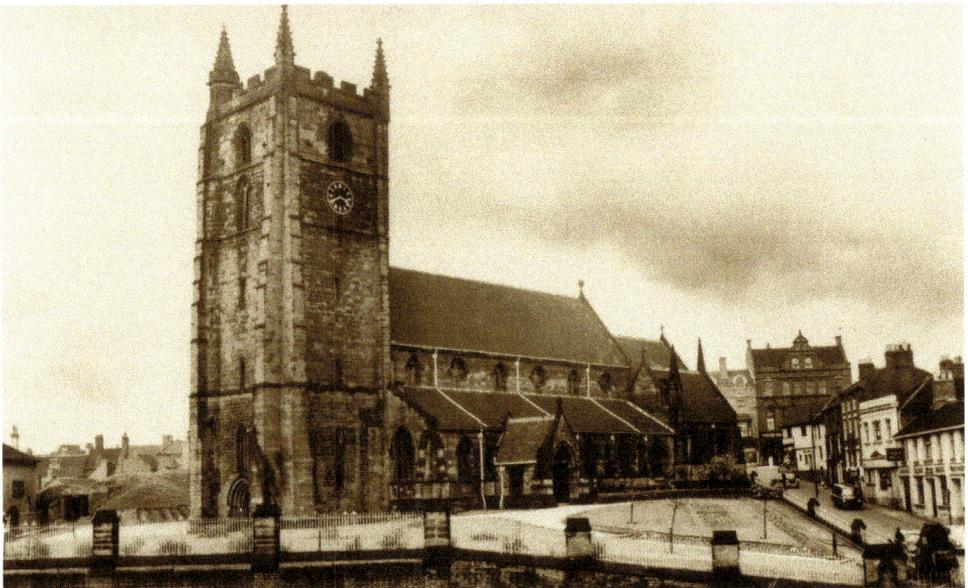

St Giles' Church, Newcastle, 1950s. Note the Central Hotel and Globe pubs in the background.

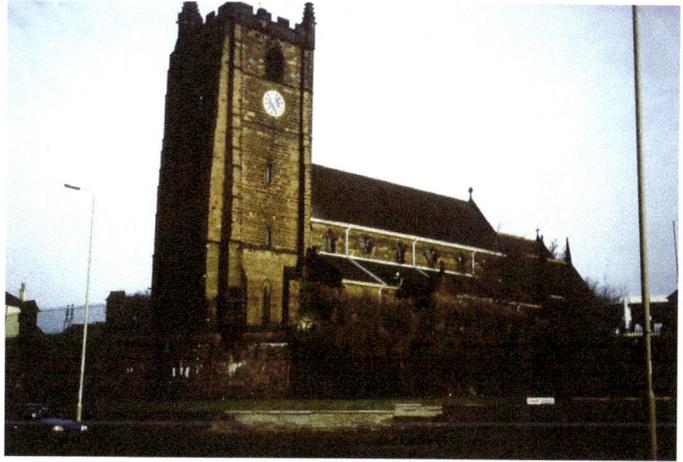

St Giles' Church, 1996.
This building dates back
to between 1873 and 1876.

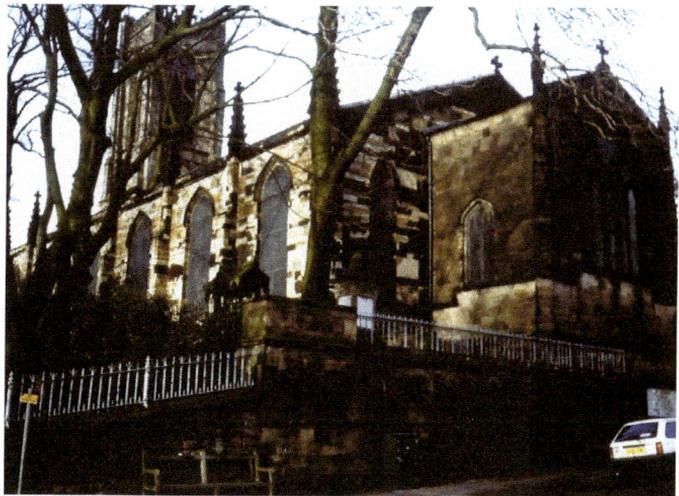

St George's Church
interior, date unknown.

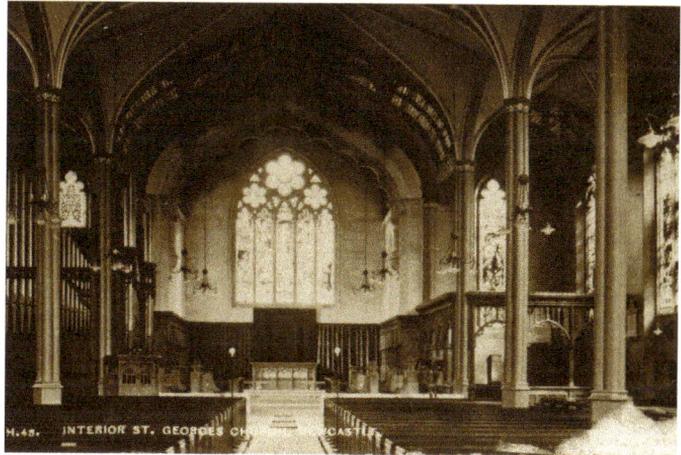

St George's Church,
1996. The church opened
in 1828.

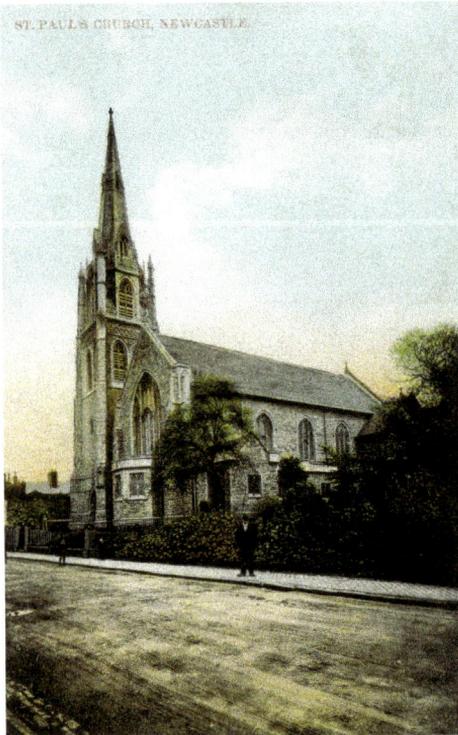

Above: St George's Churchyard, 2017.

Left: St Paul's Church, *c.* 1908.

by water, such as that encountered in the Newcastle Railway Canal and the Lyme Brook. On occasions, the perambulation appears to have descended into silliness:

> The Apedale Canal was passed by wooden planks, and here several practical jokes were perpetuated to the intense amusement of the crowd, and the discomfiture of those who found themselves unexpectedly in the water. A little further on, the Brampton Canal was crossed no fewer than three times, also on planks. The greatest fun was created by these points, a large number of boys and men being ducked. One man had the misfortune to be plunged up to the neck, and others were immersed in a less disagreeable fashion. From this stage, the proceedings became more staid in their character. In scaling the wall on the Brampton a lorry, belonging to the railway company was autocratically appropriated...

Over the years other issues ruffled the feathers of those churchgoers who were keen to preserve the sanctity of the Sabbath. Tradition had it that the bell-ringers of St Giles received ale at regular intervals in the calendar, taken to the belfry from the nearby Three Tuns public house. Two of the large jugs in which it was carried are in the possession of the Borough Museum. However, the relationship between the church and the drinks trade was not always so harmonious. In 1828, publican Thomas Clay of Newcastle was convicted by the magistrates for opening his house on the Sabbath, following the notice given by St Giles' churchwardens to apply the full force of the law to those publicans permitting tippling in their houses during divine service on Sundays.

DID YOU KNOW?
Isaac Pepper and John Dodd were fined by the courts in 1878 for digging a grave in St George's Churchyard while in a state of severe intoxication.

It wasn't just publicans who incurred the wrath of Newcastle's religious fraternity. In 1887, Newcastle Town Council heard complaints that bands were parading through the streets and playing music in the streets during the hours of church services, much to the disapprobation of the worshippers. However, was it the window-rattling beating of drums that annoyed the complainants or the competition for the hearts and souls of the public? The bands in question were described as representing 'other religious sects', with the Salvation Army and the Salvation Army Mission being mentioned by name. It was suggested that the bands discontinue playing on the streets between the times of 10.30 a.m. and 12.30 p.m., and 6–8.30 p.m. on Sundays to avoid clashing with church services.

The matter was thoroughly discussed by the council, and its deliberations tell us much about the various bodies flexing political muscle in the town. Even marketplace tradesmen had complained about the bands, claiming that it was difficult to carry on business when the music was being played. Alderman Heath stated that, some time ago,

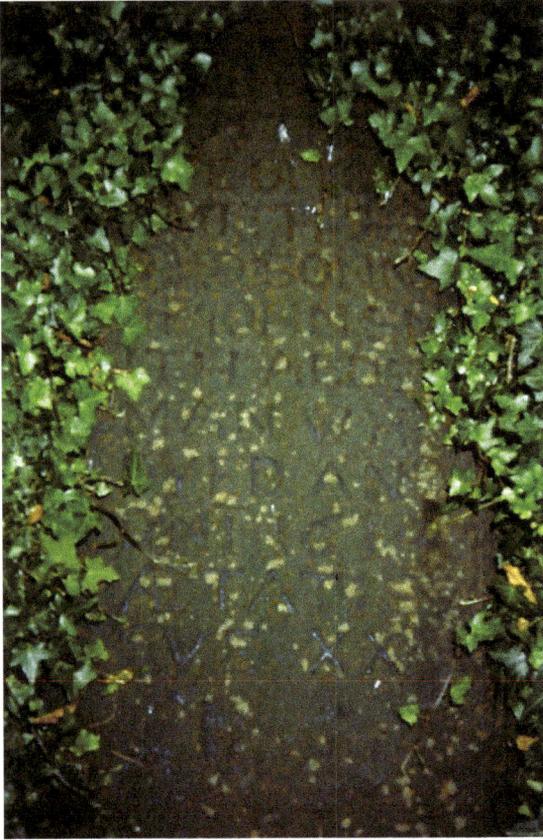

John Smith's memorial in St Giles'
Churchyard, 1995.

the worshippers in one chapel had been disturbed by the noise of a band playing outside. He described the activity as a 'desecration of the Sabbath'.

Incidentally, St Giles' Church also knew internal as well as external tensions. In 1875, some of the church's Sunday school teachers suffered a disagreement with Revd Veale and set up their own Sunday school in the Guildhall. The secessionists evidently bore a grudge. Following the opening of their new school, their company walked in procession to St George's Church, 'taking the Merrial Street route, and thus avoiding St Giles' temporary church in the Ironmarket'.

Not all churches and chapels had an untarnished reputation as moral champions. Though these places of worship were splendidly served by a number of revered clergymen over the years, we find references to some men of the cloth who brought their profession into disrepute. Such a man was Revd F. E. B. Swann, a curate of St Giles' Church. The courts heard, in 1859, that he had given his servant girl a slap, purportedly as punishment for her impudence. Swann declared in court that his assault on the girl had been grossly exaggerated but as the case proceeded he seemed to wilt under pressure:

Defendant: I wish the case was done with. A matter of a little slap! Why can't I be fined: I admit the thing!

St Giles' Churchyard, 2012.

Witness: When he struck me he said, 'Take that and go and fetch a summons.'
Defendant: The thing is most absurd. If there is a fine to be imposed, I will pay if I can; I have nothing more to say. Such an absurd, ridiculous thing as this! She says nothing about her own insolence – the provocation given. But I am not going to have any altercation with a creature like that; it is not worth my while. This is Newcastle gratitude for what I have done for it!

The mayor pointed out that this was not the curate's first transgression, and that ten days earlier a summons had been taken out against him for an assault on another servant. This latest case was proved, and Swann was fined. Leaving the room, he was heard to declare, 'I have done with Newcastle now.'

If Swann left with his tail very much between his legs, it must be said that other clergymen occasionally suffered a hard time in the course of their duties. In 1885, the *Staffordshire Advertiser* reported on a pit boy's efforts to burlesque the vicar of St Luke's Church in Silverdale during Sunday night service. Samuel Harvey – hidden from the vicar, but not the congregation – pulled on a pair of spectacles and some kid gloves in order to ape the good reverend. He caused some commotion and was ultimately locked up and fined.

Interior of Holy Trinity Church, London Road, Newcastle, 1959. This Roman Catholic church opened in 1834.

St Luke's witnessed a happier occasion in 1866, as we learn from a rather florid report in the *Staffordshire Times*. This concerned the marriage of Thomas Lawton to Mrs Mary Lawton of Woore at the church. They had loved earlier in life, but had parted. Thomas had found someone else but, exercising due caution, had courted the lady for twenty-one years before marrying her; however, she died and Thomas was left alone. During this time, Mary had two husbands and lost both of them. However, Thomas (aged seventy-two) and Mary (seventy-five) met again. This time they courted for a mere twenty-one days before exchanging vows at Silverdale.

Left: Baptist church, London Road, Newcastle, 1995.

Right: St Luke's Church, Silverdale, 1994.

Some couples who made it down the aisle did not actually tie the knot. In 1832 at St Margaret's Church, Wolstanton, a couple were in the act of exchanging wedding vows when a female relative interrupted and declared that neither bride nor groom was a parishioner. The *Staffordshire Mercury* reported, with some levity, that 'the disappointed voteries of Hymen were obliged to leave the church in single blessedness.'

9. Recreation

Leisure and recreation in the borough of Newcastle covers a diverse range of activities – both legal and illegal – and tells us much about changing tastes and moral standards over the centuries. In *Newcastle-under-Lyme 1173–1973*, John Briggs referred to bear-baiting in the town during the fourteenth century, but as late as the nineteenth century many sporting activities were organised that piqued the sensibilities of more respectable Newcastilians. However, these amusements were enjoyed by a large proportion of the lower classes. Around 2,000 people watched a fight of 'seventeen severe rounds' in one of the town fields of Newcastle in 1835. The local press yields many references to prizefighting or pugilism in Newcastle, but we occasionally find reports of bouts that plumbed the depths of barbarity. For example, in 1866, a report in the *Staffordshire Times* was entitled, 'Prize Fight. Disgusting Exhibition'. The newspaper then proceeded to describe, in graphic detail, what it called the 'sickening brutality' of a prizefight between two Newcastle men: James Whitehouse, a cooper, and Anthony Holmes, a blacksmith. This was effectively a revenge match following a previous bout, but this time the sum of £20 was set aside for the winner. It is necessary to point out that although it was crucial to keep the time and place of the prizefight secret from the local constabulary, enough of the sporting fancy of the town knew about it to place hundreds of pounds in bets on the outcome of the bout. Indeed, the newspaper report tells us much about the mechanics of arranging prizefights and the seriousness with which it was taken by the betting fraternity. Whitehouse had been trained for weeks beforehand by Jem Hodgkiss, a renowned pugilist, while two similar practitioners had prepared Holmes.

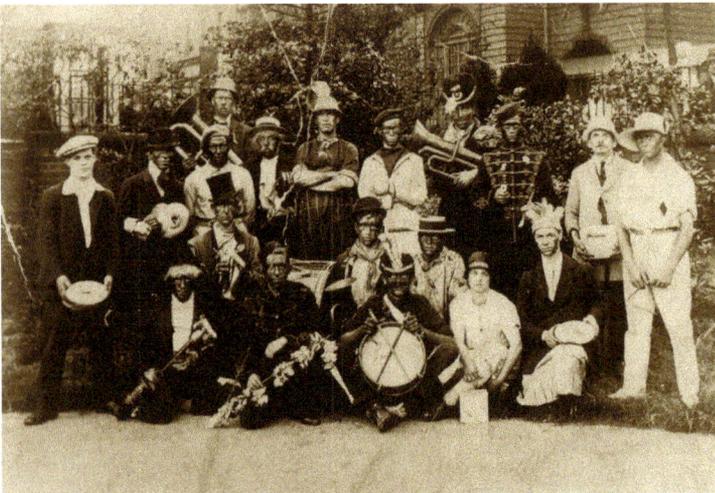

Wolstanton Jazz Band in Queen's Gardens, Newcastle, 1932.

The rendezvous place for the mill had been kept quiet until almost the last moment, and then 'conveyances of all sorts of sizes were obtained for the transit of the party'. The punters managed to leave the town without exciting the curiosity of the police and headed for the venue, with the commencement of the fight set for 3 a.m. The pugilists and their entourage travelled to Cellarhead, where a suitably private spot was found for the sport, and a ring was made. Holmes won the toss and chose the higher ground. Both men were 6 feet or more in height and both were very strong, with Holmes having a decided advantage in weight. In the first round, Whitehouse struck his opponent a terrific blow on his left eyebrow, putting him on his back. Holmes, face bleeding, hauled himself up for the second round, but after some heavy challenges were acquainted with the turf once again. Over the next four or five rounds the baying crowd enjoyed an intriguing contest, with Holmes showing his great strength and Whitehouse his superior agility and tactical prowess. By the seventh round Holmes' face 'had been reduced to a pulp and presented a horrible spectacle'. Stubbornly, he battled on, suffering further blows to his face to the extent that some fight-goers in the crowd were sufficiently sickened to slope away from the ring and keep a distance until the finish of the fight.

DID YOU KNOW?

The more primitive forms of entertainment, enjoyed by the working classes in the early nineteenth century, attracted huge crowds. At Knutton Heath (the present Silverdale) in 1843, a ring was formed with ropes and paling in preparation for a dog fight. At least four dogs were involved, with one of the battles arranged for £25 a side. However, the arrival of the police prevented the sports from taking place – much to the annoyance of a crowd of 500.

Shortly, Holmes' face was so battered that even Whitehouse's second registered his disgust that Holmes' man was allowing the fight to go on. However, the butchery was allowed to continue, with Holmes showing incredible stubbornness and pluck in the face of Whitehouse's ferocious onslaught. His final blow on Holmes was described as 'something like a blow on sloppy clay, and blood gushing out and sprinkling some of the spectators'. Holmes' second finally threw in the sponge. The twenty-one rounds had lasted for just over thirty minutes and Holmes was carried home, a handkerchief having been placed over his pummelled face. The only wonder is that he survived this beating, as is indicated by the resultant course case, which saw both pugilists being fined by the magistrates.

Though the Whitehouse/Holmes confrontation was particularly brutal, other prizefighters sustained terrible injuries in lengthy contests. A fight between George Sargeant of Burslem and Levi Caton of Goldenhill took place in 1842 at Dunkirk, between Newcastle and Chesterton, with Sargeant being declared the winner after around two hours and forty-seven rounds. Two men – Dean and Hawkins – fought each other for

two hours in a field at Bradwell Wood in 1871. It was reported that 'Dean was so badly punished that he [the police officer who caught them] did not know him. He was covered in blood. Hawkins was also badly hurt and could scarcely get away.'

A bout that took place in Newcastle in 1893 saw local pugilist 'Bonser' Hewinns taking on James Kennedy of Birmingham for £5 a side. Nine rounds were fought over forty minutes, with the Newcastle man outscoring his opponent for much of the mill, before Hewinns unleashed some mighty punches. Though both men were badly hurt, Kennedy was reported to have 'had the sight of one of his eyes destroyed'.

Interestingly, the attraction of organised fisticuffs lingered for decades, though it became at least a little more respectable – a fact that may have been lost on many present-day Newcastilians but for a letter to the *Sentinel* in 2003. In it, G. R. Tweedie from Talke Pits recalled the fairground that was set up adjacent the Sutherland Arms pub in Blackfriars Road in the mid-twentieth century, which incorporated a boxing booth. Between 1948 and 1951 Mr Tweedie was one of many former servicemen boxers with Ernie Plant's travelling boxing booth; he wrote:

> From a raised platform outside a large tent with ring inside, promoter Nipper Plant challenged all-comers from large crowds gathered to take any of us on for three or six rounds for money. We had many challengers in a packed tent who were mostly also ex-service. In those days, pubs shut at 10 pm and we boxers would stroll over to the Sutherland Arms for a pint and often see challengers we had beaten.

Many working-class sports revolved around betting, incurring disputes and bad feeling. Foot racing was hugely popular and taken just as seriously as pugilistic contests. It is well known that crowds of around 3,000 sometimes gathered on Wolstanton Marsh to watch these sprinters, but if we trawl the nineteenth-century newspapers we find interesting reports of some of the quarrelling and shenanigans that accompanied the sport. Two runners from the Potteries competed for £25 each on the Marsh in 1838. Imagine the

Wolstanton Marsh in the 1980s.

rumpus that occurred when the leading runner, Yates of Goldenhill, was legged down a short distance from the finish. The stakes were consequently divided, though not, we suspect, without much arguing. Another race in 1841, over 120 yards, saw Newcastle's Bolton Phillips triumphing over William Henshall of Hanley, but there followed a great disturbance among rival supporters that would no doubt have annoyed locals living on the edge of the Marsh. We know from a *Staffordshire Times* report of 1865 that the popularity of Wolstanton Marsh as a venue for multifarious sporting contests had implications for those who resided nearby. Various visitors to the Marsh brought along their dogs in connection with rabbit racing events, but not all of them left quietly. One particular case referred to a dog that had been rabbit running and which had spotted two turkeys belonging to a local resident. 'The owners of the dog deliberately picked up the turkeys and walked off with them,' stated the magistrate. 'It appeared to him that the men who attended these schemes after their racing was over were ready to pick up anything that lay in their way.'

DID YOU KNOW?

There are numerous references in the local press to foot racing in the borough of Newcastle. This became a popular spectator sport, especially as bets were placed on the outcome of these sprints. However, some racers took the sport very seriously. In May 1868 two boys were summoned for running races in Seabridge Road, Newcastle, 'divested of every encumbrance in the shape of clothing'. They were both fined by the magistrates.

Pedestrian feats involving long-distance walking were often a crowd-puller, with the result that these took place around pub bowling greens or recreation grounds, proving very lucrative for the organisers. Some indefatigable foot-sloggers just wanted to walk for the fun of it as did 'Old Joe Mason, the well-known Newcastle character' in 1907. Leaving the town, he walked through Macclesfield, Manchester, Halifax, Keighley, Skipton, Settle, Kirby-Lonsdale, Kendal, Penrith, Carlisle, Annan, Dumfries, Thornhill, Kirkconnel, Newcummock, Cummock, Hurlford and Kilmarnock before reaching Glasgow, where his prodigious effort was confirmed by Post Office officials. He was slightly delayed by some heavy weather but arrived in Glasgow having been walking for a little over two weeks and having covered nearly 300 miles. He was sixty-eight years old. The *Staffordshire Sentinel* reported that Mason had telegrammed a contact in Newcastle, claiming to feel 'as strong as a horse' and promising to walk back home.

Feats of physical endurance came in many guises, but often drew crowds of spectators. Anyone who has competed in the Mow Cop Killer Mile road race will testify to the difficulty of ascending the slope to the stone folly at the summit. In the past, cycling up it has proved equally challenging. A Manchester youth by the name of Wood rode up on his pedal cycle in September 1929, when it was stated that this had only been accomplished

once before – around eighteen months previously. A few weeks later, five members of
the Apollo Cycle Club in Manchester attempted to repeat the feat. Two managed it – in
six minutes, twenty one and a half seconds – but the other three could not do it without a
momentary rest.

At this chronological distance, the so-called Sport of Kings might perhaps seem less
likely to have incurred the displeasure of more upright and seemly members of the
public in the nineteenth century – after all, some of them were involved, not only in
its support, but also in its organisation. The Newcastle Races of the mid-1860s came off
at the Stubbs Field and were efficiently arranged affairs involving hunt stakes, a ladies'
plate, a publicans' plate, etc. The local newspapers listed the handicaps and runners,
while stabling for the horses was offered by hostelries such as the Roe Buck Hotel in the
town. The public flocked to the grandstand and to the refreshment booths and enjoyed
sideshows such as the roulette tables and shooting galleries. Though the racing was not of
high standard – some races were started by only three horses – it was taken very seriously,
and a list of conditions and rules was printed in the newspapers with all disputes to be
settled by the Race Committee.

Queen's Gardens, Newcastle,
early 1970s.

Queen Elizabeth Gardens,
Newcastle, 1994.

However, these amusements were frowned upon by some of the religious elements in the town, who resented the fact that these events were sometimes held at the time of Newcastle Wakes, which by this time had lost its former significance as a celebration of the Feast of St Giles and had become something of an annual knees-up and a chance for the toil-worn working classes to let their hair down. In 1865 one newspaper correspondent – evidently unable to accept that the Industrial Revolution had changed the nature of the Wakes forever – excoriated the replacement of what had been a festival of the church with sideshows and races: 'an annual standing evil of the town', he declared. He described the races as a public nuisance and the cause of misery and sin under the guise of outward decency (Edmund Buckley, the former MP for Newcastle had been announced as a steward at the 1864 races). The correspondent painted a graphic picture of dark and hellish scenes, half-bred sporting jockeys and crowds of silly folks, of swearing, gambling and drinking; yet the contributor, who used the pseudonym of 'X,' admitted in his letter that notices for the races were 'blazoned forth in every shop and corner' – surely an indication of their popularity. Thus did establishment figures in the town of Newcastle struggle to come to terms with changing patterns of working-class recreation in the town. The value of newspaper letters like this is that they offer views and reaction to reported events that convey much about our forefathers' prejudices, anxieties and perceptions, and are therefore as useful to history students as the nineteenth-century news stories that triggered them.

DID YOU KNOW?

Following the Holditch Colliery (Chesterton) disaster of 1937, a football match was played in aid of the disaster relief fund. Stoke City drew 0-0 with Glasgow Rangers at the Victoria Ground in Stoke. It was announced after the match that it had attracted 28,000 spectators and had raised over £1,600.

A relatively short-lived recreational pursuit in Newcastle was roller skating. The North Staffordshire Skating Rink Company opened a rink near to the town's railway station in 1876. The rink measured 150 feet by 60 feet and a third of it was under cover. It was ambitious for its time, incorporating a refreshment room, a cloak room, a covered promenade and sufficient space to accommodate a musical band.

Our green spaces in Newcastle-under-Lyme have been described in many books, though it is not generally known by many people that a well-known item of militaria that has been displayed in two of the town's recreational areas may not have survived to tell the tale. The Crimean War cannon of 1840 was captured at the end of the Crimean War in 1856 and presented to Newcastle in 1857. For many years it was sited in Stubbs Walks. However, during the salvage drive of the Second World War it was contemplated by the town council that the cannon be handed over to the Ministry of Supply as scrap metal. There was a feisty debate in council circles. Advocating the item's removal,

Councillor Ryles reminded his colleagues of the number of children who had been hurt near to it. Alderman Harper believed that its metal would be useful to the war effort and that sentiment should not be allowed to prevail. However, Alderman Hodgkinson, the chairman of the Parks Committee, declared that it should remain for historical reasons and Alderman Myott viewed that it was of interest to older Newcastilians and that their feelings should be considered. The cannon ultimately survived and was re-sited outside Newcastle Borough Museum in 1965. It still poses a danger to the children who insist on climbing on it, but is as fondly regarded by Newcastilians today as it was in 1941.

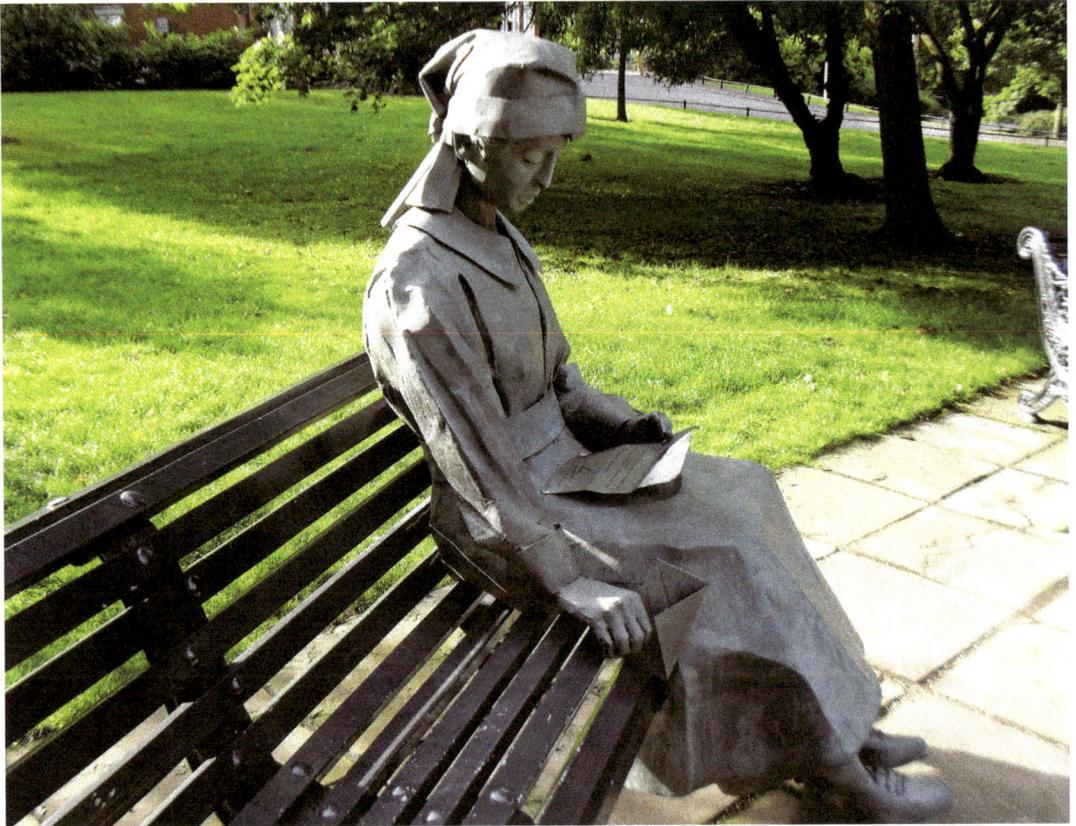

Brampton Park, 2015.

10. Public Houses

Publicans offered a wide variety of games and attractions all calculated to prolong the elbow-bending of their patrons. The landlords were often well placed to organise community events based around their premises, though were not guaranteed to behave with decorum at all times. For example, one of the publicans at Chesterton was charged on licensing day in 1832 for 'suffering a bull to be baited during the wake, opposite his premises'. The press report goes on to explain that he was warned beforehand that he would likely incur the displeasure of the magistrates, but that nevertheless the bull was baited over three or four days. The magistrates refused to renew his licence. Cockfighting arrangements at Newcastle's Shakespeare Hotel in the late eighteenth century were regularly advertised in the local newspapers.

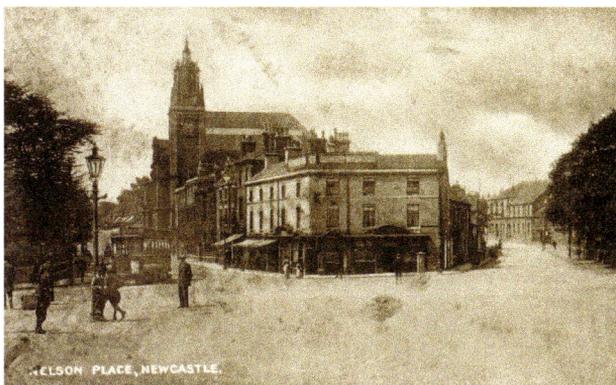

Compasses pub and Nelson Place, date unknown.

Sutherland Arms, Newcastle, 2003. It was demolished in 2006.

Dunkirk Tavern, 2010.

Throughout history, pub landlords have promoted indoor games. The King William the Fourth in Bagnall Street, Newcastle, was advertising a quoit ground by 1875. The Borough Arms offered billiards, while the Bird in Hand in Hassell Street, the Vine Inn in Bridge Street and Wolstanton's the Jolly Potters were among many pubs that incorporated a skittle alley. Some pubs specialised in music hall style entertainment, such as the Fox and Goose in Lower Street, Newcastle. Here, in 1856, it was possible to see – for a short time only – the Great Kentish Giant, described as 'the tallest and largest in England'. He stood at 7 feet four inches and weighed in at 24 stones and 5 pounds. He could reach to a height of 10 feet and 6 inches and had an arm span of 8 feet. He measured 9.5 inches around his wrist and 3.5 around his little finger. A man 6 feet high could stand beneath his arm.

Occasionally a publican incurred the wrath of so-called respectable society by staging attractions that were judged to be unacceptable; however, it is doubtful whether the hotel keeper of the Talbot Hotel in Church Street would have foreseen the furore that ensued upon his advertising, in 1876, 'A Grand Barmaid Contest' to take place on his premises. Three gold watches, valued at £30, were announced as being prizes and the pub was specially decorated for the occasion. If it is true today that elements of the feminist lobby might take issue with such a competition, it was certainly true in 1876 that the moral champions of the town of Newcastle vehemently opposed the Talbot's event. There was a swift backlash led by Frederick Allen, the Newcastle MP. So strongly did he feel about the barmaid contest that his letter to the *Staffordshire Times* drew comparison between the

event and the notorious 'man and dog fight' that had (reportedly) taken place in Hanley in 1874. Allen urged all respectable people to boycott the event in the good name of the loyal and ancient borough. There came a withering response from Thomas Basford, keeper of the Talbot Hotel, who praised respectable barmaids and advocated the right of respectable innkeepers to run their business without such interference. However, other correspondents were quick to take up cudgels for Mr Allen, including 'A Wesleyan', who denounced such 'dreadful imitations of London shows' and 'An Old Tradesman' who opposed what he called 'women shows' and the like.

DID YOU KNOW?

A pub in Merrial Street honoured the name of the 1st Duke of Wellington, whose victorious campaign at Waterloo ended the Napoleonic Wars. However, the coronation of William IV took place on 8 September 1831 and prompted a name change. When the pub was up for sale in November that year it was described as being 'lately known by the name or sign of the Duke of Wellington but now of King William the Fourth'. By the by, a William IV in Bagnall Street is listed in *Cottrill's Directory* (1836).

Ultimately, Samuel Hyslop saw fit to give an opinion on the matter. Hyslop was the proprietor of the Borough Arms Hotel and the chairman of the North Staffordshire Licensed Victuallers' Society, which had been set up a decade earlier to raise standards in the trade. To Hyslop, the barmaid contest at the Talbot cut against the grain. He felt that at a time – only a few years after the Licensing Acts of 1869 and 1872 had legislated stringently against some aspects of the licensed trade – when publicans were subjected to intense scrutiny, it was putting weapons in the hands of opponents to stage such events as barmaid contests. In defence of Mr Basford, Joseph Blakoe, the resident manager of the Talbot, wrote to the *Staffordshire Times* and declared that the contest had been his idea. He struck back at the 'self-constituted guardians of the public morals'. There appears to be more reaction to the contest than reportage of it, though for all the controversy it caused it seems to have been successful. Hyslop's letter intimated that Allen's advice to the public to stay away had not been heeded and that 'rumour says it has been a great harvest'. Blakoe's contribution mentioned that it had endured for 'some days'.

Pubs often incorporated large assembly rooms that were ideal for the meetings of various societies. Female groups were not particularly common, but one seems to have been very well supported in Chesterton in 1881. This was the Female Friendly Society, which held its first tea party and concert in the Eagle and Child Hotel in December. The society had only been formed a few months previously, and its aim – like those of other, similar groups – was to provide assistance for its members in time of sickness and death. The meal was followed by a concert and entertainment provided by the Silverdale Glee Party. However, not all pub visitors acted with respect for the premises. Public houses saw

all kinds of drunken behaviour, with various offenders being well-known to the police. These were colourful characters, to put it mildly.

In 1867 it was reported that George Lucan – 'alias Lord Lucan' – a renowned rag gatherer had once again been charged with drunkenness. According to the *Staffordshire Times* George appeared in court, standing in the dock, looking 'for all the world like a huge baboon tarred and rolled in rags'. He pleaded that he had never tasted drink until the day before, but the court was having none of it, meting out an appropriate penalty. It's unlikely that he'd heard the magistrate's verdict, anyway, as he fell asleep in the dock, while the business of the court proceeded.

Also fined for a rather odd transgression was Hanley fishmonger James Robertson, who ventured to the Hanging Gate in Newcastle in 1874. A fellow drinker remarked to the intoxicated Robertson that the young sheep dog in the house was a nice dog. The fishmonger replied, 'Yes, it is, but its tail is too long.' Another tippler joked, 'You'd better shorten it,' at which point Robertson took up the dog and bit off the end of its tail. He was subsequently fined for drunkenness and cruelty to the animal.

DID YOU KNOW?
In 1949 a collection of twenty artists' designs for inn signs was staged by Ind Coope & Allsopp Ltd at the Sea Lion in Hanley. One of the designs – by the well-known artist Miss M. E. Murray – then hung outside the Jolly Potters in High Street, Wolstanton. However, it is difficult to impress everybody. The local press stated that, 'Some have said that one of Miss Murray's potters looks like a future case for the Silicosis Board, but she leaves no doubt about their jollity.'

Of all the notorious drunkards whose baneful presence struck terror into the hearts of publicans and law-abiding drinkers, one name springs readily to mind – as much for his longevity as a trouble-maker as for his reputation as a nuisance to his own community. Benjamin Hollins was a Silverdale collier, and his misdemeanours were regularly reported in the local press from at least 1862 until at least 1886. Age did not mellow him, and over the years various publicans or beer sellers must have dreaded a visit from Hollins, whose disorderly behaviour was known at such as the Royal Oak, the Swan and the Crown in Silverdale and the Cheshire Cheese in Newcastle.

An earlier reference to Hollins reports on his knocking another man down in Penkhull Street, Newcastle, in 1862. He later pleaded that he had mistaken his man, but this was just the sort of beer-triggered, brutal behaviour that would land him in trouble for years. Hollins rarely paid his fines and court costs and was often sent to prison for three- or four-week stints, which at least gave Silverdale people some brief respite from his incorrigible misdeeds. Never mind publicans and beer sellers, Hollins thought nothing of attacking those plucky police constables who came to arrest him. In 1865, Constable Benton attempted to eject him from a watering hole and was struck several times before

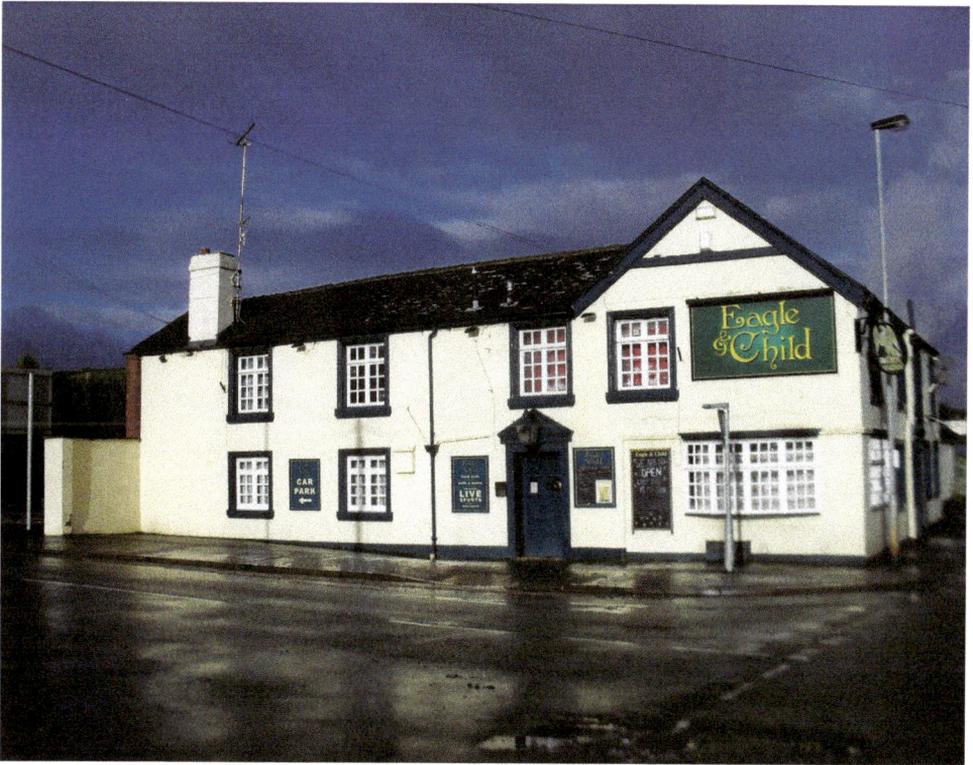

Eagle & Child, Chesterton, 2016.

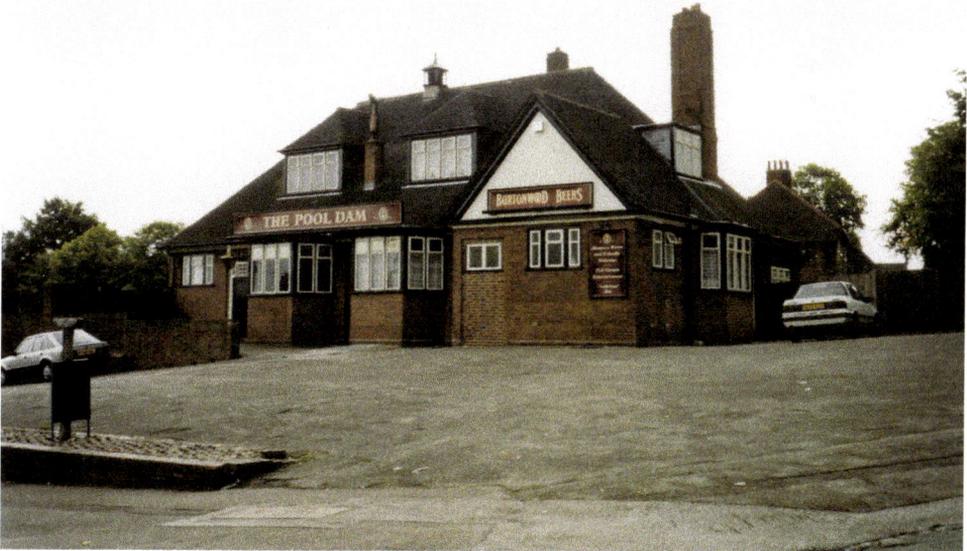

Pool Dam, Newcastle, *c.* 2002. It was demolished in 2010.

being rolled in the mud outside. As a burly collier, Hollins feared no man, and in May 1870 he was seen to take his coat off in a Silverdale street and offer 'to fight any person who was desirous of trying his skill in fisticuffs'. It is clear that the courts lost count of the number of times he appeared before them. The *Staffordshire Times* records what was believed to be his fiftieth court appearance in October 1878, while the month after he was said in court to have had thirty-six previous convictions. Sometimes he had barely been out of prison a couple of days before reoffending. Taking a drunken Hollins into custody was a tricky process that often left police constables with bruises. While being locked in a prison cell in April 1884, it was reported that he assaulted his fellow prisoners and behaved like a madman. It was for good reason that the *Staffordshire Knot* described him as 'not a credit to the peaceable inhabitants of the growing colliery village', following his fifty-eighth conviction in 1886.

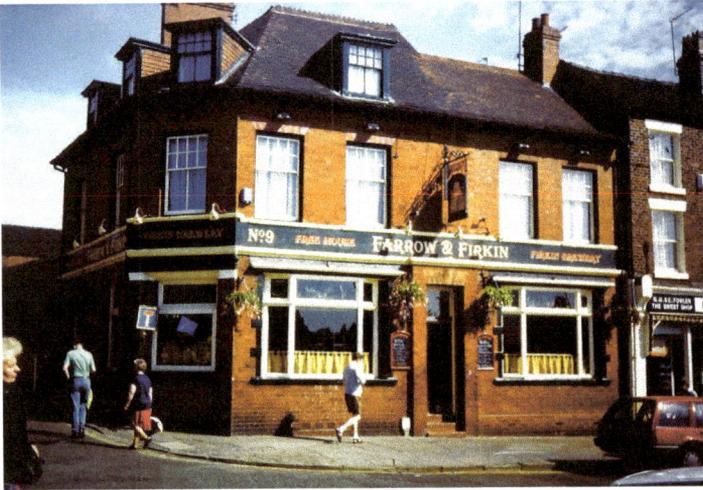

Farrow & Firkin, Newcastle, 1994. It has been known by many names, though historically it was the Bird in Hand.

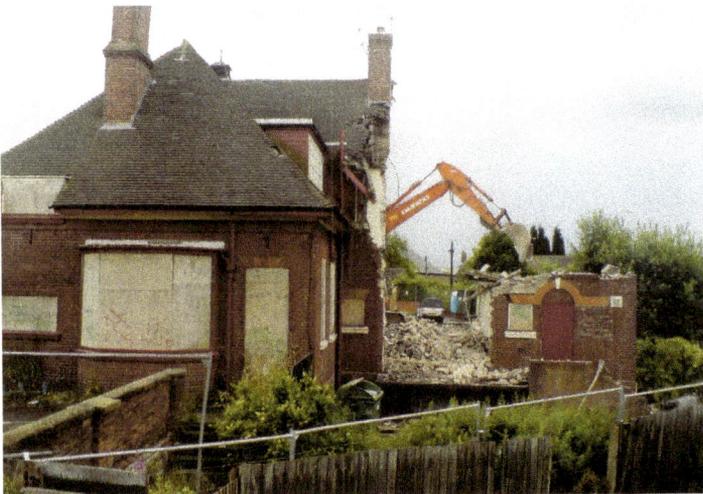

Castle Tavern, Newcastle being demolished in 2009.

Other disturbances in hostelries were a product of the societal framework that placed the pub at the centre of the community, allowing it an elevated role that served the public for good and for bad. Take a court case that was reported in the *Staffordshire Advertiser* in 1872 in respect of the Foaming Quart beerhouse in Silverdale. On the occasion in question, a Silverdale forge mill man by the name of Proudman was paying his workers their wages on the premises. Clara Simpkin arrived asking for her husband's wages – Mr Simpkin was a teetaller who refused to enter the beerhouse himself. She pointed out the unfairness of her husband being required to call there for his wages – surely not an unreasonable stance. However, the beer seller proved not to be a reasonable man. Emerging from his cellar, he threatened to eject her and put his fist through her face. He denied charges against him in court, also pleading that he did not usually pay wages at the Foaming Quart but he had required some change at the time. He was fined 20s and costs.

DID YOU KNOW?

There sometimes comes a time in a man's life when he has to bury his wife. Unfortunately, one Chesterton collier tried to do this while she was still alive! The *Staffordshire Knot* reported in 1884 that 'Mad Jack' Rowley got drunk and dug a hole in his garden, subsequently pushing his wife into it. When she refused to lie down quietly, he struck her over the head with his spade. The *Knot* quite rightly made the point that the magistrates, in only charging Jack for being drunk and disorderly and fining him 10s plus costs, were letting him off lightly.

The nature of a publican's trade was such that many landlords had tales to tell by the time they retired, including George Edward Onions, who nearly drowned in his own pub in 1954. In August of that year, a severe thunderstorm gave rise to much flooding in Chesterton, and virtually the whole of Dragon Square was left underwater. Newcastle fire brigade had to pump flood water away for several hours, while Onions suffered much damage to his pub, the George & Dragon. During the worst of the storm, and with Dragon Square already inundated, he descended to his cellar in order to inspect his barrels of beer. He was about to ascend his cellar steps when the force of water smashed through his cellar windows and poured in. In a short time the cellar, which was 7 feet from floor to ceiling, was flooded to the roof. 'Cases of bottled beer were thrown about like nine-pins' by the surging water. Three-dozen pint glasses were smashed and all the draught beer was spoiled. In due course the flood water entered the bar and other downstairs rooms. The widespread flooding in Chesterton also affected the Bennett Arms at the lower end of the village, with the stream at the back of the pub overflowing. Barrels of beer floated in the cellar and some burst open. Mrs Peake, the licensee's wife, told the local press that she was afraid to go out at night on account of the rats from the brook. Regrettably, problems were to recur for these two pubs.

~ GROUND FLOOR PLAN ~

RWP

HT5'1"
ELV 3'1"
DINING ROOM

LOUNGE
MAIN
FIRE PLA

TILED
FLOOR

ARCHED
DECORATIVE
LIGHT

SWINGING
DOORS

YARD (PAVE

HT 4'0"
ELV 3'6"

KITCHEN
QUARRY

T×G
HT 5'1"
ELV 3'1"

HT 5'1"
ELV 3'1"

HT 4'0"
RWP ELV 4'0"

RWP

Steam Plough, Victoria Street. Architect's plan showing ground-floor premises in 1981.

Torrential rain in August 1958 again affected the George & Dragon, where the brewery decided to install a special pump to combat future inundations. 'The outside drains in Dragon Square just can't cope with the floods,' explained pub manager Alf Pierce. As regards the Bennett Arms, letters were written and a petition raised by its licensee in 1971, in respect of the brook, known as the Grumbles by local residents and said to be a 'breeding ground for vermin'. This was an obvious problem for the Bennett Arms, for by November 1971 its cellar was reported to have 'flooded for the sixth time recently'.

Many of the pubs mentioned in this chapter have been demolished or suffered change of use, so that information on them housed in private archives may truly be regarded as ripe for inclusion in *Secret Newcastle-under-Lyme*. For instance, the Steam Plough in Victoria Street, which closed in 1980 is now a private house but many drinkers of a certain age recall its tiny interior. Others who used it in their remote youth may only vaguely recall the ground-floor interior layout. Hopefully, the accompanying extract from an architect's plan of the premises may refresh the memory.

About the Author

Mervyn Edwards is the author of twenty published books on North Staffordshire history (including this one) and is a weekly columnist for the *Sentinel*'s 'Way We Were' nostalgia magazine. He has appeared on the BBC's *The One Show* and *Twenty Four Hours in the Past*, is a familiar voice on Radio Stoke, and has also contributed to BBC Radio Four's *Broadcasting House* programme. He was a local history tutor for the Workers' Educational Association for eight years and helped to develop the education department at the now-defunct Chatterley Whitfield Mining Museum, where he often acted in period drama for school groups.

Mervyn runs an annual history programme in North Staffordshire. He is the entertaining emcee of Burslem History Club and a member of the Potteries branch of the Campaign For Real Ale (CAMRA).

Outside of local history, Mervyn enjoys power walking and jogging. He has completed seventeen Potteries Marathons and other races, and in 2014 completed his first Mow Cop Killer Mile in thirteen minutes. He has completed several long-distance charity walks, sometimes in his beer bottle costume. In 2005, he was the pacemaker for mining historian Keith Meeson on a 60-mile walk of former colliery sites helping to raise money for the Donna Louise Trust.

Acknowledgements

My thanks go to Nobby Clarke, John Cooper, Kenneth Edwards, Mrs Gibson – head teacher of Ellison Academy –Harold Hemson, Gordon Howle, Darren Knowles, Keith Meeson, Shaw's Postcard Publishers, Romana Sidoli, Gary Tudor, the staff of Newcastle Reference Library and the Warrillow Collection at Keele University Library.

Every effort has been made to correctly identify copyright owners of the photographic material in this book. If, inadvertently, credits have not been correctly acknowledged, we apologise and promise to do so in subsequent reprinted editions.